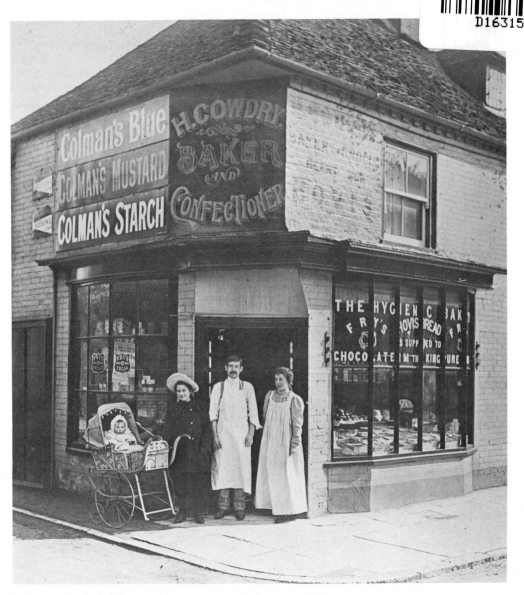

1 Henry Cowdry's bakery and grocers shop, Wimborne, *c.* 1905

2 *Overleaf* William Churchill, 1897. In his essay *The Dorsetshire Labourer*, published in 1883, Thomas Hardy noted – '. . . the genuine white smock-frock of Russia duck and the whitey-brown one of drabbet, are rarely seen now afield, except on the shoulders of old men. Where smocks are worn by the young and middle-aged, they are of blue material.'

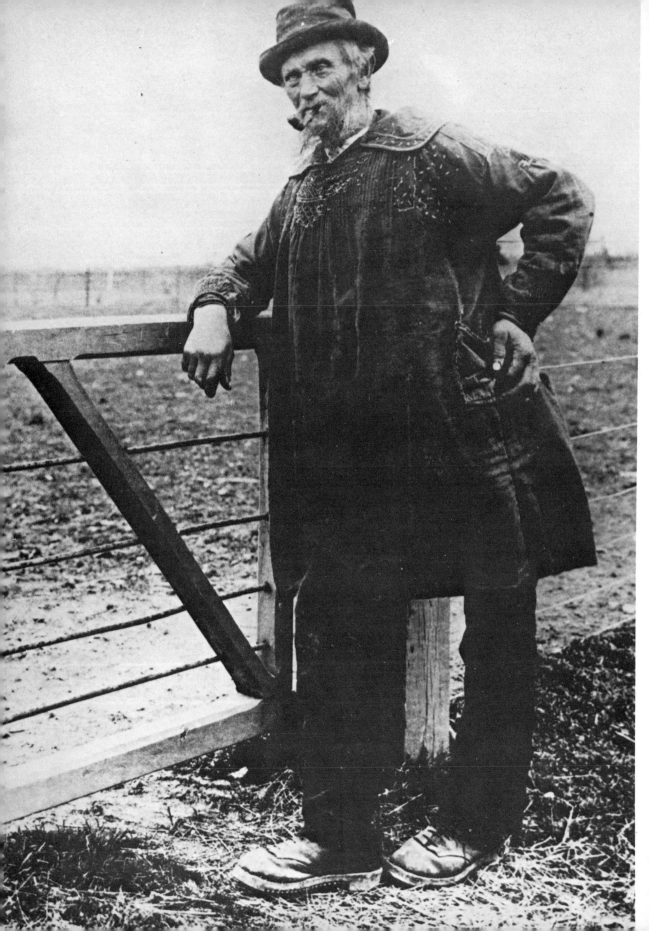

Victorian and Edwardian

DORSET

from old photographs

Introduction and Commentaries by
PETER IRVINE

B.T. BATSFORD LTD.
LONDON

First published 1977
Copyright Peter Irvine 1977

Filmset by Servis Filmsetting, Manchester
Printed in Great Britain by
The Anchor Press Ltd, Tiptree, Essex
for the Publishers B.T. Batsford Ltd
4 Fitzhardinge Street, London W1H 0AH

ISBN 0 7134 0148 6

CONTENTS

ACKNOWLEDGMENTS

The Author and Publishers would like to thank the following for their assistance and for permission to reproduce the photographs included in this book: Birmingham Public Library (Sir Benjamin Stone Collection) nos 16, 31, 32, 125; Bridport Museum nos 24, 45, 46, 47, 70, 90, 96, 121; Mr Bulkley, Sturminster Newton no. 95; Dorset County Library nos 5, 6, 7, 8, 11, 12, 15, 17, 23, 30, 48, 49, 51, 57, 62, 73, 81, 83, 84, 86, 94, 129, 132, 133, 134, 135; Dorset Military Museum nos 115, 116, 117, 118, 119, 122; Cecil Durston, Portland nos 80, 82, 89, 93; Eddison Plant Hire Ltd nos 108, 109, 110; Gillingham Local History Society Museum nos 50, 53, 69, 102; Peter Lyford, Sturminster Newton no. 130; F. Morris, Portland nos 33, 38, 112; John Oldfield, Lyme Regis nos 13, 14, 36, 92, 106, 113; Anthony Pitt-Rivers nos 26, 34, 61, 76, 127; Priest's House Museum, Wimborne nos 1, 42, 43, 44, 59, 72, 74, 77, 99, 103, 124, 139, 142, 143; Radio Times Hulton Picture Library no. 60; Raymond Rogers, Sturminster Newton no. 55; Shaftesbury Local History Society Museum nos 9, 19, 39, 40, 100, 111, 114, 123, 140; Mr Sharp, Marnhull nos 54, 107; Sherborne Museum Association nos 66, 78, 79; Sherborne Public Library no. 128; J. Stevens-Cox, Guernsey nos 2, 3, 4, 10, 18, 20, 21, 22, 25, 27, 28, 29, 35, 37, 52, 58, 63, 64, 65, 67, 68, 71, 91, 97, 98, 101, 136, 137, 141; Swanage Public Library nos 75, 88; Miss Taylor, Ashmore no. 56; Wareham Museum nos 105, 120, 126; Weymouth Public Library, nos 41, 85, 87, 104, 131, 138.

INTRODUCTION

A visitor to the pretty flint church of St Mary in the Dorset village of Tarrant Gunville, having paused a while to reflect upon the sombre words carved on the outside of the chancel wall:

HERE LITHE S.T.D. PARSON
ALL FOWRE BE BUT ONE
EARTHE FLESCHE WORME AND
BONE. MCCCCCLXVII.,

may enter to find another memorial tablet of perhaps greater interest – that which commemorates Thomas Wedgwood, son of Josiah the potter and a pioneer in the field of photography. As early as 1799 Thomas had already carried out experiments in the basic principles of photography, obtaining images of leaves by placing them in contact with paper coated with a solution of silver nitrate, a chemical which darkens on exposure to light. Unfortunately, he did not discover a means of 'fixing' the resulting image before his death in 1805 and as his 'sun prints' soon darkened on exposure to daylight they had to be kept in permanent darkness and gazed upon 'furtively by the weak light of a candle'. However, his friend Sir Humphry Davy declared: 'Nothing but a method of preventing the unshaded parts of the delineation from being coloured by exposure to the day is wanting, to render the process as useful as it is elegant'.

Twenty years were to pass before the Frenchman, Nicéphore Niepcé produced the first fixed image, but the next three decades saw rapid advances and the work of Louis Daguerre (who produced direct positives on metal – known as daguerreotypes) and William Henry Fox Talbot firmly established photography as a practical proposition. By the 1860s professional photographers were to be found in all the larger Dorset towns, listed in the contemporary trade directories between pastrycooks, patten makers and pianoforte manufacturers, amongst them the Misses A. & E. Barrett, who made portraits of the genteel holidaymakers of Lyme Regis, at their studio in the Butter Market, and Adam Gosney, 'photographic artist' of Sherborne, who advertised 'cartes de visites in two positions' at eight shillings a dozen and 'views and slides of all places of interest in and near Sherborne' from sixpence each. There was also a place for the amateur. Major John Warry of Holwell, for example, was an early enthusiast who made use of Frederick Scott Archer's wet collodion process (which involved the use of sensitised glass plates) to produce a graphic record of mid-nineteenth-century Dorchester and its society.

The amateur photographer really came into his own in the 1880s when George Eastman's Kodak camera, cheap and easy to operate and using roll films, brought photography within the reach of the masses and created a revolution paralleled by

the bicycle craze of that era. In Dorset an Amateur Photographic Association was formed and a member of this society, the Reverend T. Perkins from Turnworth, addressed the members of the Dorset Natural History and Antiquarian Field Club in 1893 'On the desirability of a photographic survey of the county'. Speaking of 'the wholesale destruction' of buildings of historical interest and architectural merit together with the changes taking place in village life and customs, this enlightened and far-seeing rector called for the making of a photographic record before it was too late.

He envisaged a visual accompaniment to the written word of Thomas Hardy: 'His books are photographs, so to say, in words; but I should also like to see photographs in permanent platinum salts of such men and women as Gabriel Oak with his sheep on the Downs, Tranter Dewy with his hogshead of cider . . . and poor pure Tess among the cows on the dairy farm, or hacking swedes on the bleak hills of central Dorset'. His listeners on that summer evening, secure in the twilight of Victoria's reign, could have little idea of just how far reaching those changes were to be and, fortunately for their peace of mind, no idea at all of the holocaust which awaited the next generation and which would change forever the world as they knew it. The images on the following pages, moments of being trapped by the amber of Man's craft, give us a link, however tenuous, with that lost sepia world, gone to dust as surely as the composer of those lines in the churchyard of Tarrant Gunville foretold.

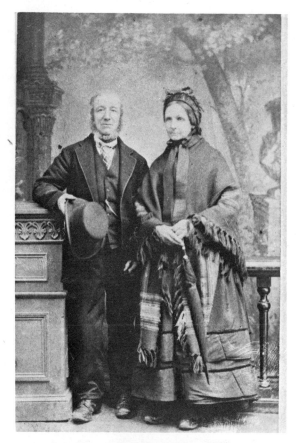

3 A Dorset couple, c. 1865. A carte-de-visite taken in the studio of Adam Gosney, 'photographic artist' at Dorchester. In a contemporary directory, Mr Gosney advertised: 'Cartes de Visites in Two Positions, per Dozen 8s.; 6 for 4s. 6d.'

4 The village store, Puddletown, c. 1905

Aye, at that time our days wer but vew,
An' our lim's wer but small, an' a-growen;
An' then the feäir worold wer new,
An' life wer all hopevul an' gaÿ;
An' the times o' the sprouten o' leaves,
An' the cheäk-burnen seasons o' mowen,
An' binden o' red-headed sheaves,
Wer all welcome seasons o' jaÿ.
From William Barnes, 'Childhood'

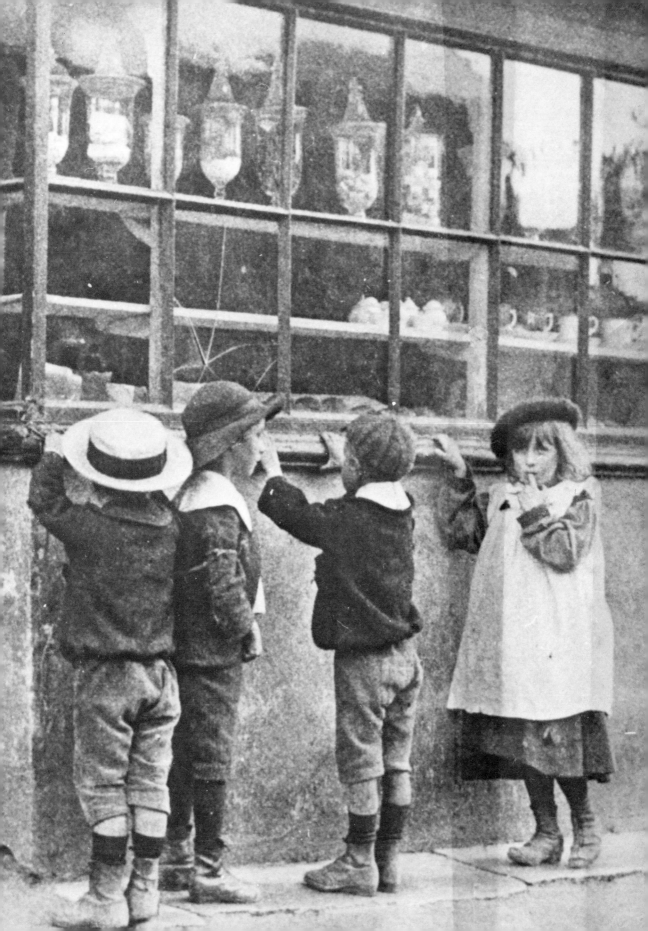

THE TOWNS AND VILLAGES

5 High East Street, Dorchester, *c*. 1900

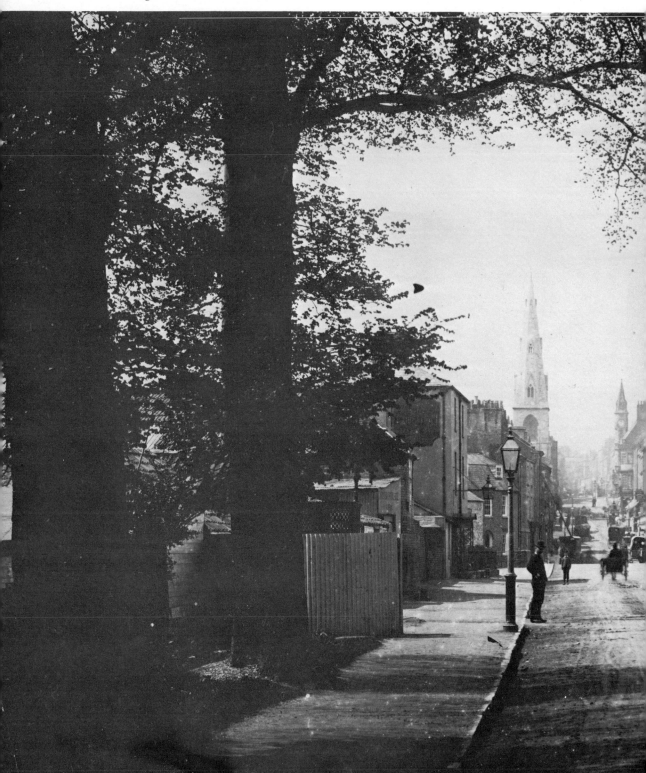

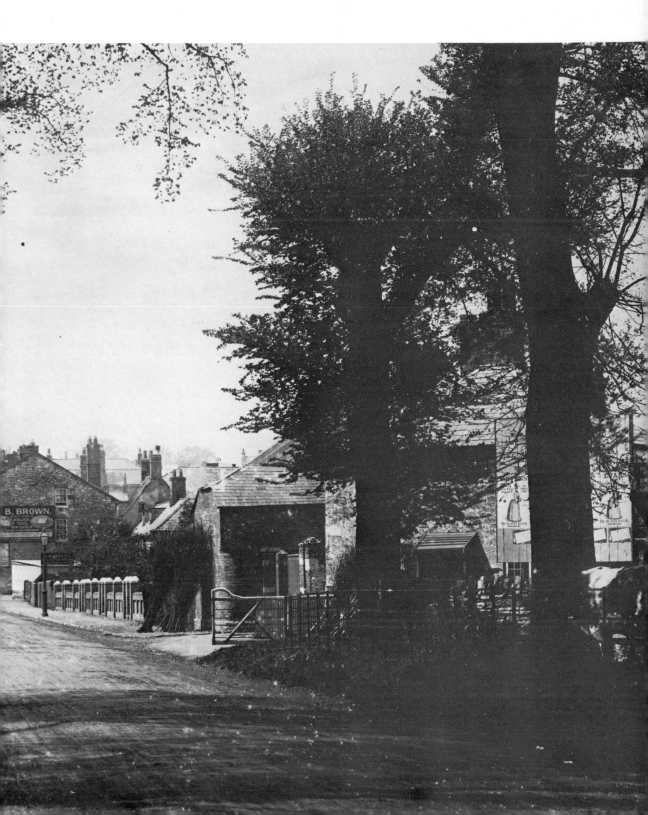

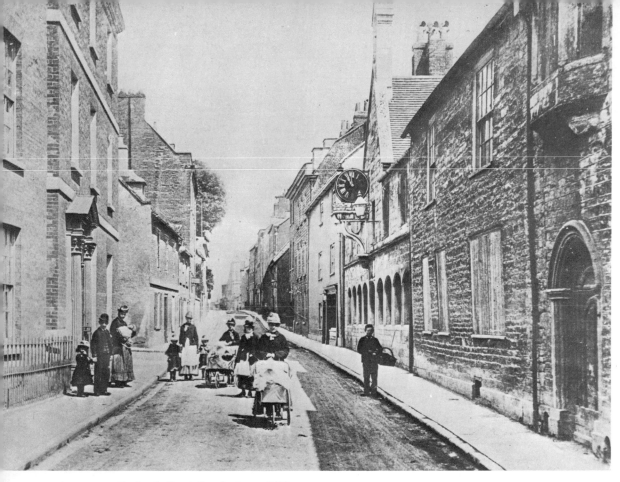

6 South Street, Dorchester, *c.* 1860

7 Old Holy Trinity Church, Dorchester, *c.* 1860. The church, which replaced one destroyed by fire in 1824, was itself pulled down in 1875 and the present building erected. Note the knife-grinder's cart

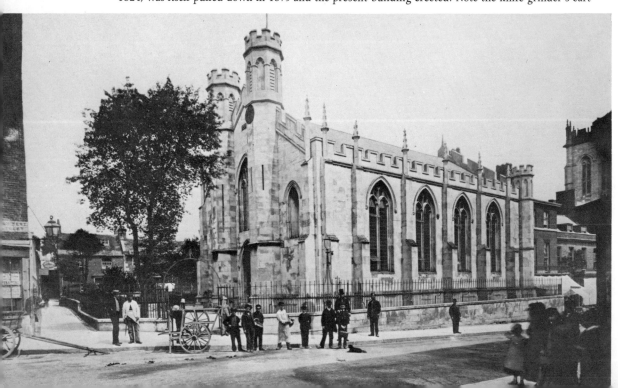

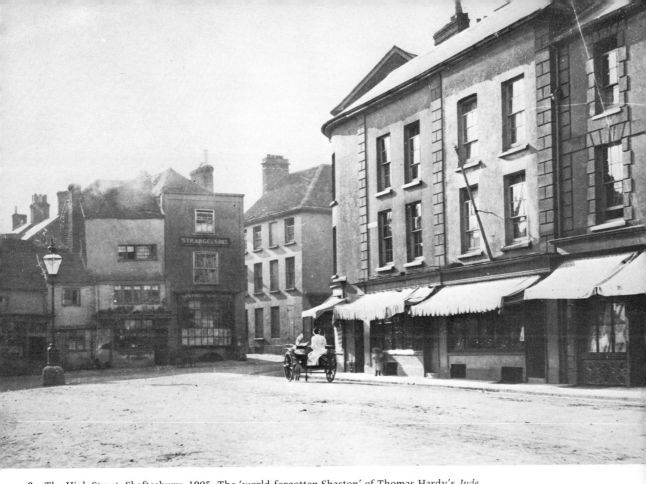

8 The High Street, Shaftesbury, 1905. The 'world-forgotten Shaston' of Thomas Hardy's *Jude* slumbers in the haze of an Edwardian summer afternoon.

9 The Commons, Shaftesbury, *c.* 1890. The yellow horse-bus stands outside the Grosvenor Hotel; a lumbering six-seater, it met the trains at Semley Station on the London & South Western Railway

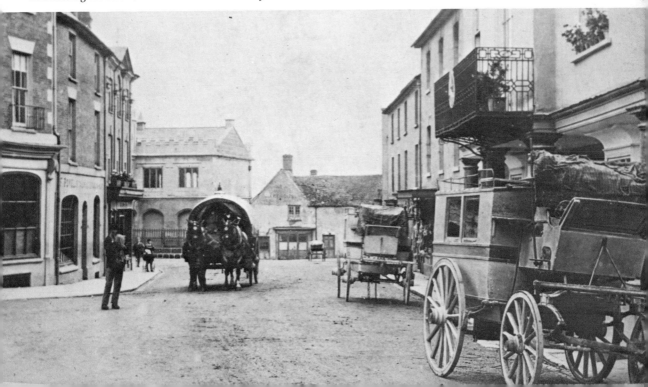

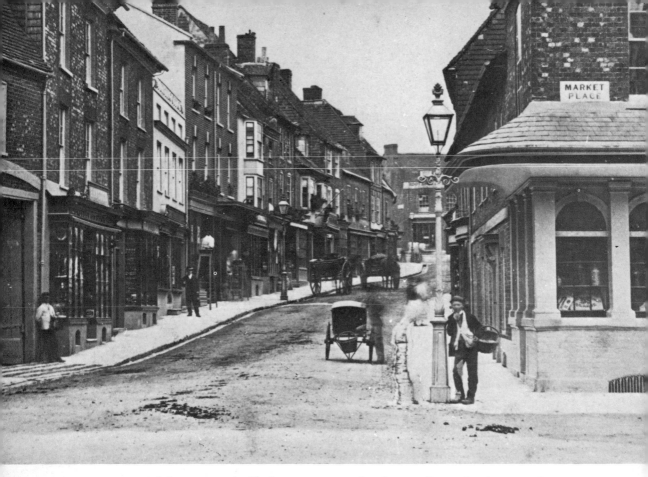

10 Salisbury Street, Blandford Forum, *c.* 1875. This photograph was taken by J.S. Hailes, photographer and bookseller, whose premises were in Salisbury Street

11 West Stafford, *c.* 1890

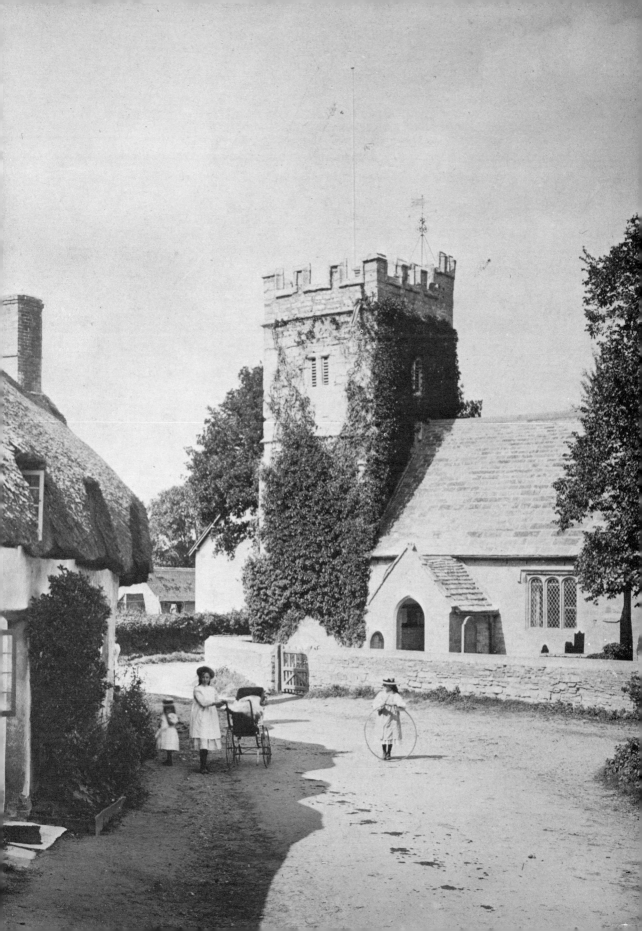

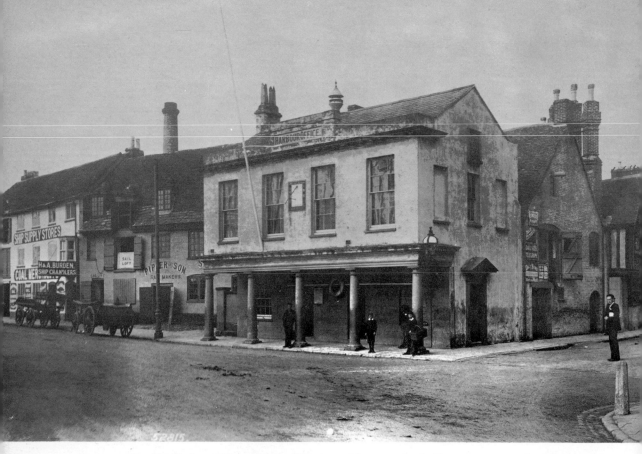

12 The Harbour Office, Poole, *c.* 1910, '. . . with an arcade of pillars convenient to lean against, and a life-buoy hanging up in the shade. Next to the office is the very homely Steam Packet Inn, then comes a sail loft with ample dormer windows in the roof, then a ship chandlers with a cosy bow window for old customers.' (Sir Frederick Treves)

13 *Right, above* The Assembly Rooms, Cobb Gate, Lyme Regis, *c.* 1870. Now demolished, the Assembly Rooms were the centre of the town's social life during its heyday as a Regency watering-place; with afternoon teas, card parties and dances every Tuesday and Thursday

14 *Right* Broad Street, Lyme Regis, 1857. Robert Hawker, proprietor of the New Inn, is described in a contemporary directory as 'licensed to let horse and carriages and bath chair proprietor'. Next door at the Red Lion Richard Foulkes ran the daily omnibus to Axminster

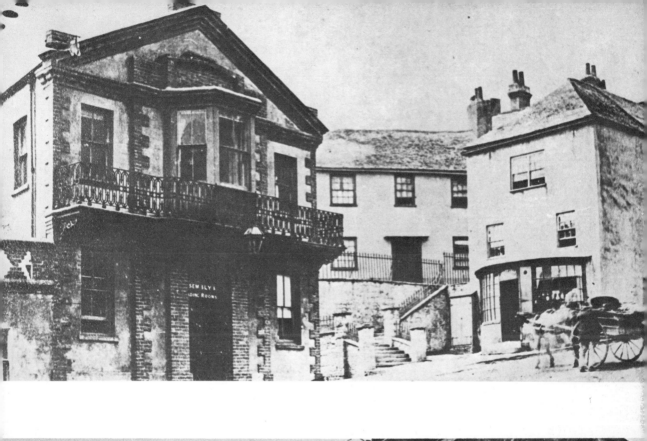

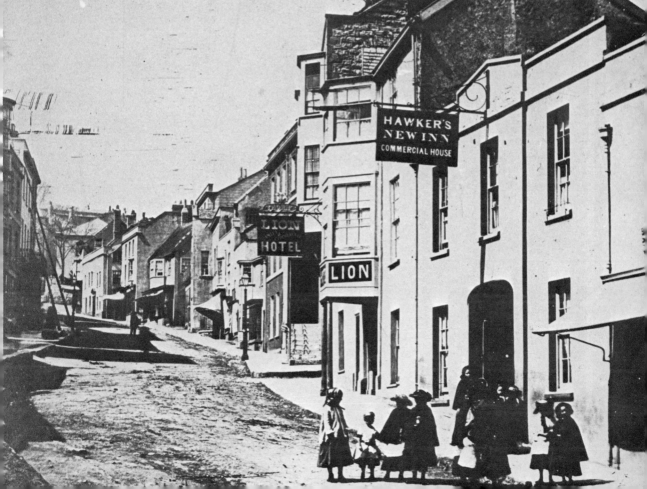

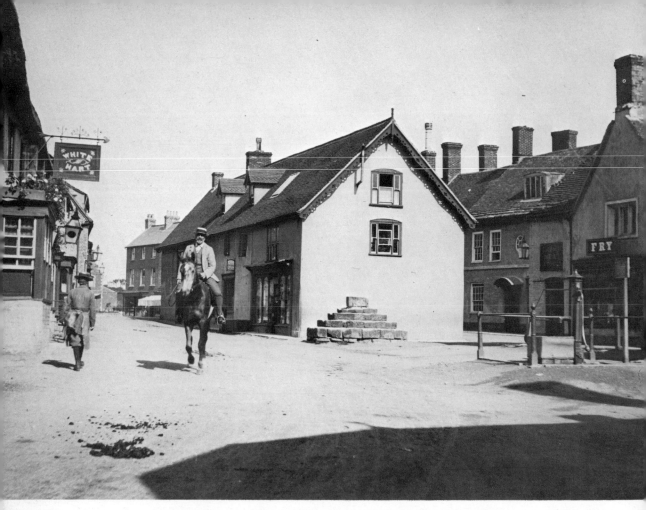

15 The Market Cross, Sturminster Newton, *c.* 1905. John Fry's saddler's shop can be seen behind the town pump: 'The latter is of wood, is small, black and vixenish. On it is a notice spitefully warning the passer-by that he will be prosecuted if he does it hurt, and adding further that no children must use the exclusive structure. There is a sourness in this, for all children delight to play with pumps.' (Sir Frederick Treves)

16 Abbey Passage, Sherborne, 1905. St Aldhelm had become the first bishop of Sherborne in 705 and the anniversary of this event in 1905 included a spectacular pageant

THE PEOPLE

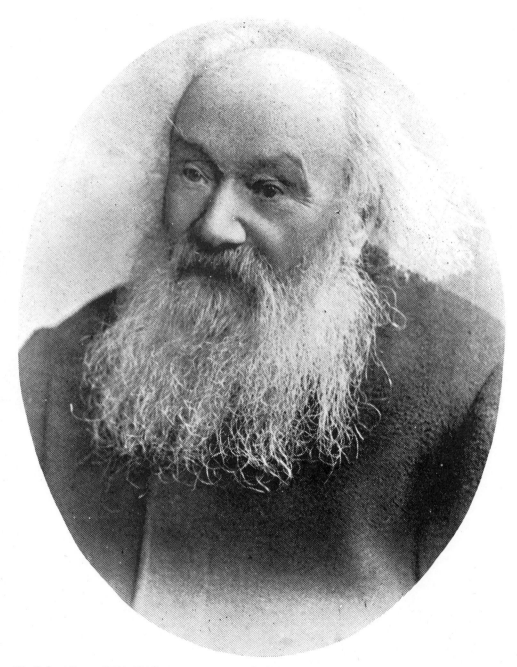

17 Robert Young (1811–1908). A contemporary of William Barnes and a fellow native of the Blackmore Vale, Robert Young lived at Sturminster Newton where, under the name of 'Rabin Hill', he wrote humorous dialect verse

18 A Beaminster couple, outside their cottage near Meerhay Manor, c. 1890

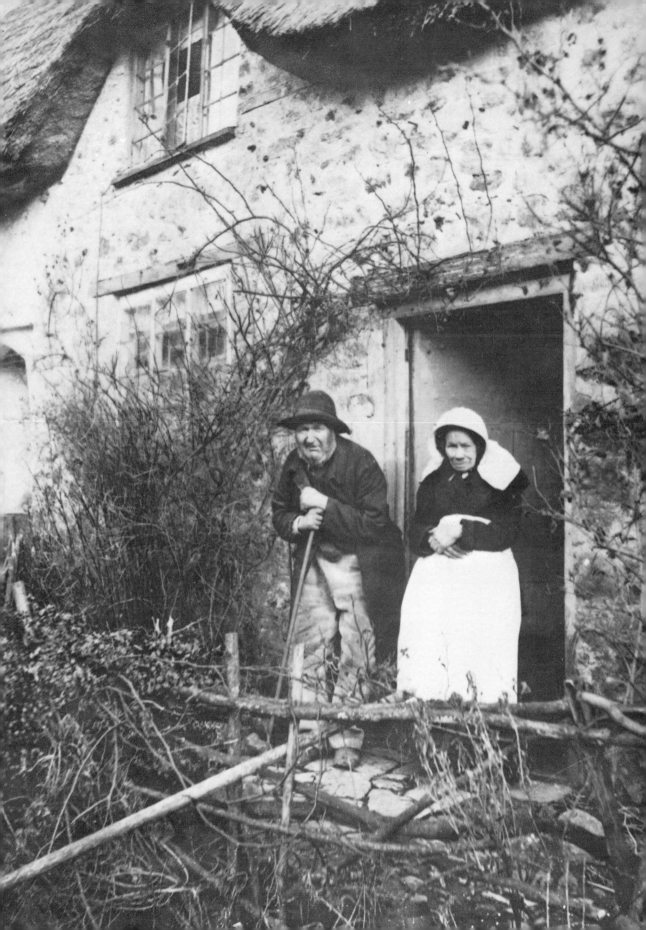

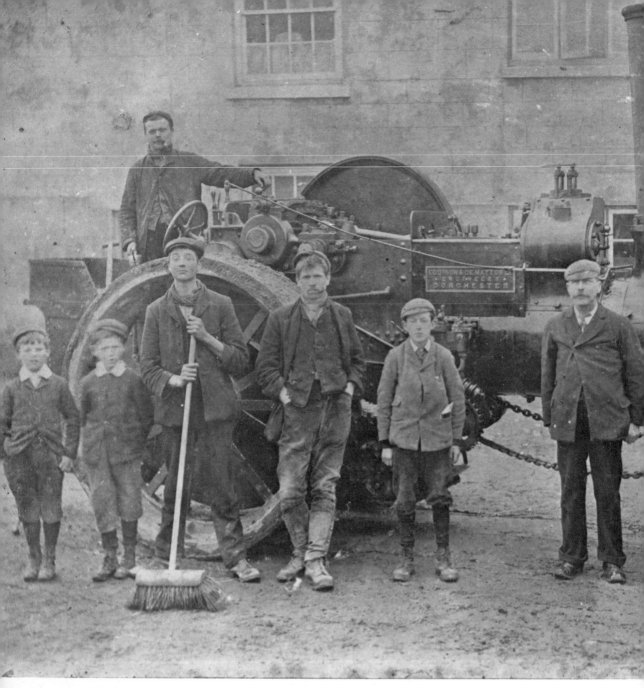

19 A team of road menders outside the Half Moon Inn, Shaftesbury

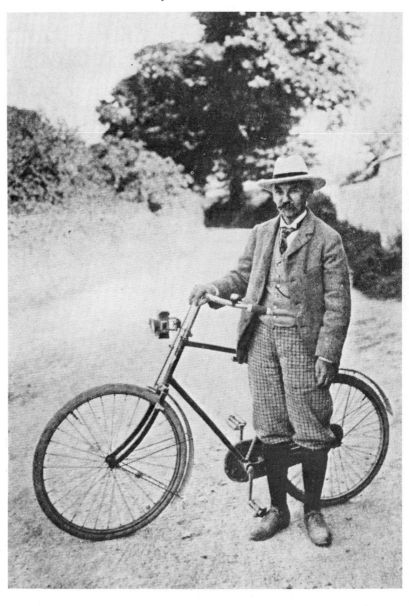

20 Thomas Hardy with his bicycle, 1899. Hardy was a keen cyclist and at the age of 59, when the picture was taken he would still tour 50 miles in a day

21 and **22** Dorset characters, *c.* 1890

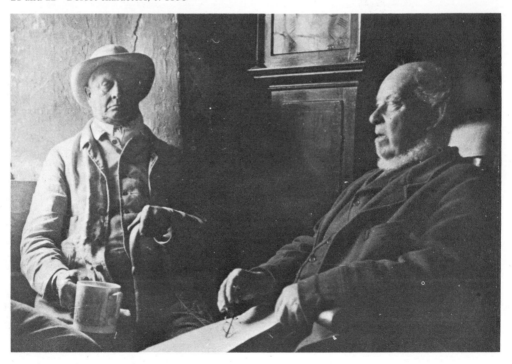

23 *Right* Dialect poet, philologist, teacher and folklorist, William Barnes (1801–1886).
This photograph, or 'sunprint' as Barnes would have it, is probably the one mentioned by his daughter
as being taken in 1870: 'Some of his friends insisted on taking the poet to the studio of a
fashionable artist-photographer to have his likeness taken, and a very successful portrait was the
result.'

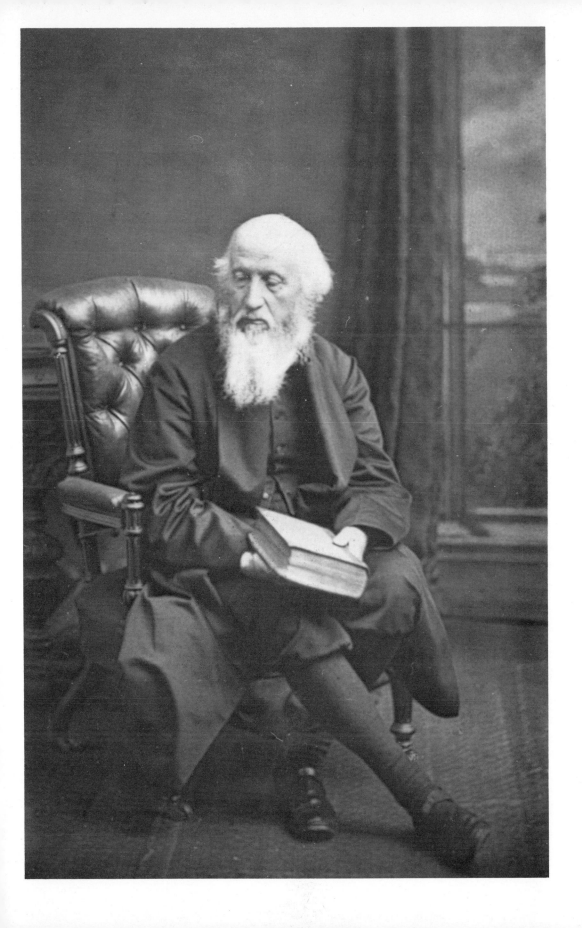

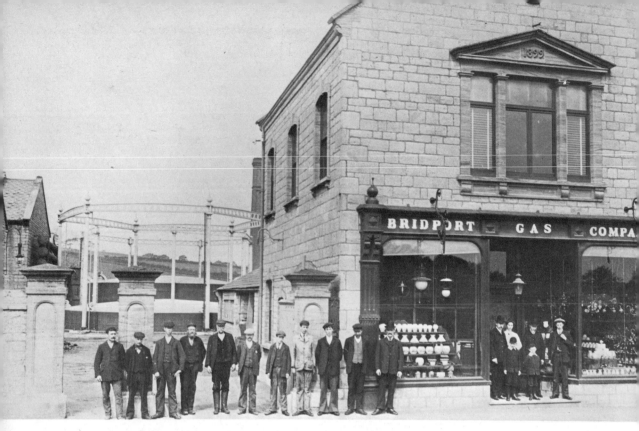

24 The premises and staff of Bridport Gas Company, 1906. James Cornish, the manager, stands in the doorway with his family

25 Robert Larcombe, parish clerk of Blackdown, *c.* 1890

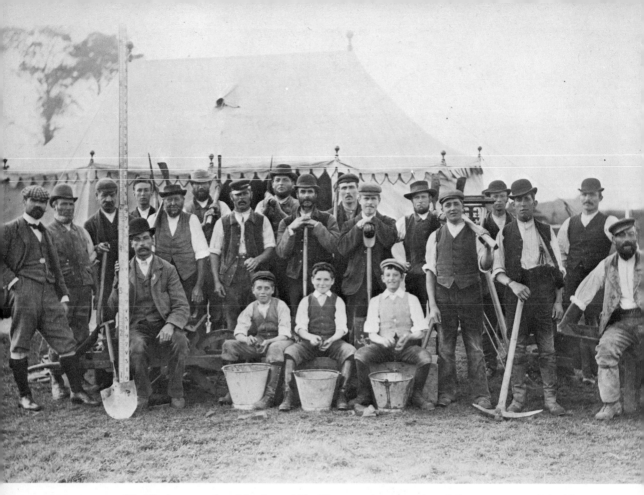

26 Workmen employed by General Pitt-Rivers on the excavation of the Romano-British building at Iwerne, in the autumn of 1897. The General thought highly of his men: 'Some of the workmen, of whom I employed from eight to fifteen constantly, have acquired much skill in digging and detecting the relics in the several villages and tumuli that have been examined, so as to entitle them to be regarded as skilled workmen, upon which no small share of the success of an investigation of this kind depends.'

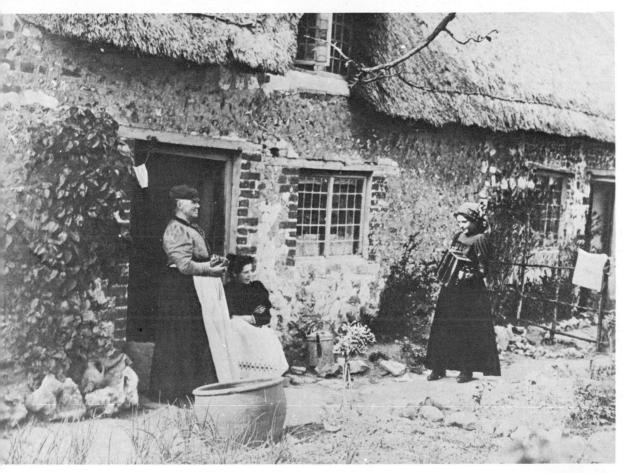

27 Dorset cottagers, *c*. 1900

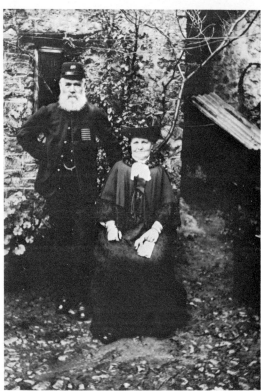

28 'Dad' Swaffield, the
Beaminster postman, and his
wife, *c*. 1900

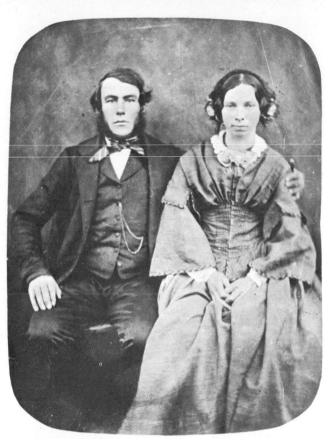

29 A Dorchester couple, *c.* 1890

30 *Below* Thomas Hardy at a rehearsal of *The Mellstock Quire* adapted from *Under the Greenwood Tree* by A.H. Evans, who is sitting on his right

31 *Right* Male inmates in the cloister of Sherborne Almshouse, 1905, 'where the old men sit and smoke, dream in the sun over the past, and wait for the end. Here can be heard, mumbled by toothless mouths and jerked out by the stems of cherished pipes, the rare, enchanting dialect of "Dosset".' (Sir Frederick Treves)

32 *Right, below* Female inmates of Sherborne Almshouse

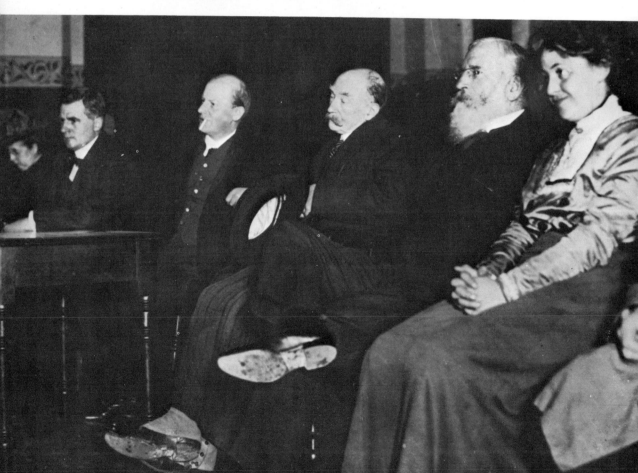

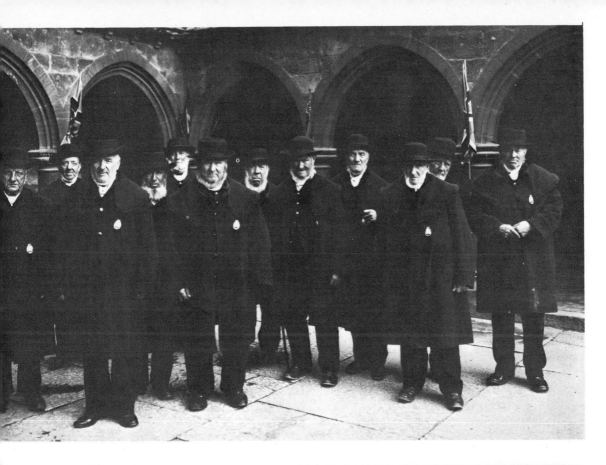

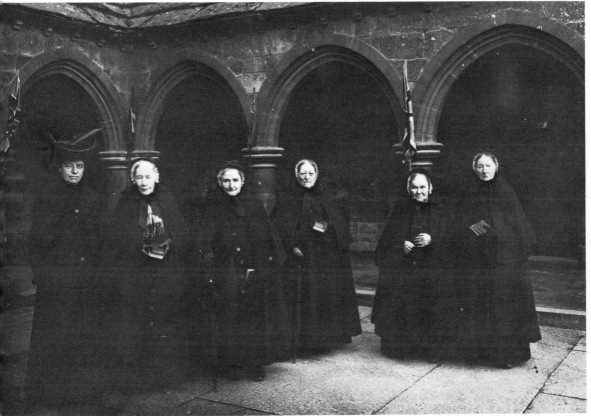

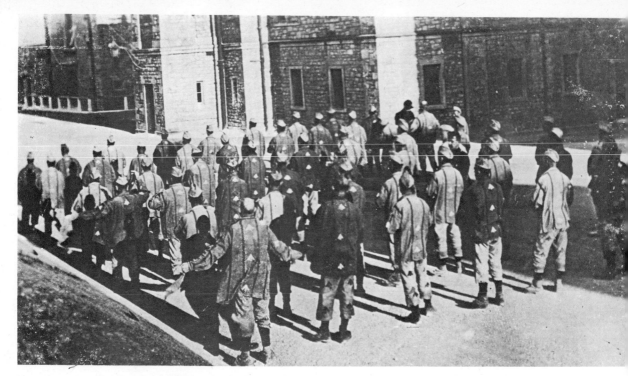

33 Portland Prison was built in 1848 to house the convicts employed in the construction of Portland Breakwater and the bleakness of existence within its grim walls must have filled the heart of even the most hardened of criminals with despair. Many of the visitors to the island, in the morbid fashion of the time, came with the express purpose of catching a glimpse of the convicts. 'To have tea and see the convicts' was a popular pursuit among Edwardian holiday-makers. Here the convicts are being searched on their return from the quarries. Photograph *c*. 1909

34 Blacksmith's shop, Portland Prison, 1909. Jabez Balfour, who wrote a book describing his experiences in several English prisons in the 1890s, said that 'there was as much difference between Portland and Parkhurst or Wormwood Scrubs as between Ratcliffe Highway and St James's Street'

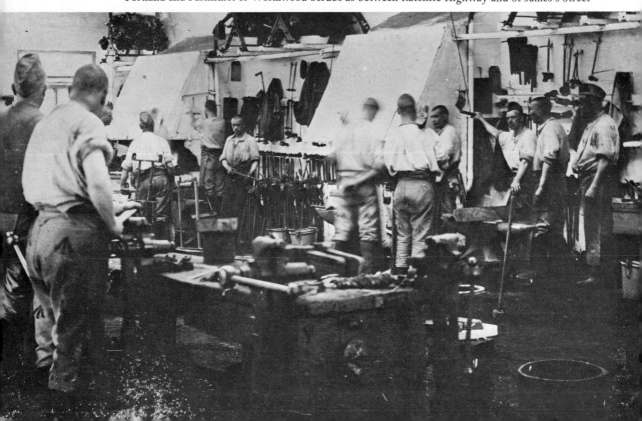

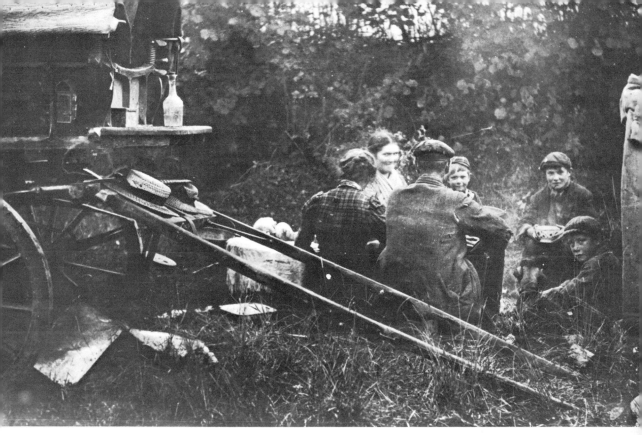

35 *Above* Gypsies camping near Hinton St Mary, *c.* 1890 **36** *Below* Gypsies on the Dorset Heath, *c.* 1895.

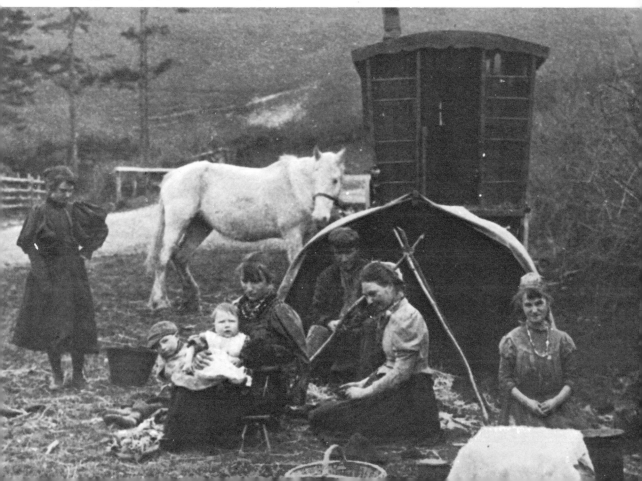

SHOPS

37 The Old Fossil Shop, Bridge Street, Lyme Regis, *c*. 1900. 'Here can be purchased, at the same counter, fresh prawns or fossil ammonites, filleted soles or pieces of a saurian's backbone.' (Sir Frederick Treves)

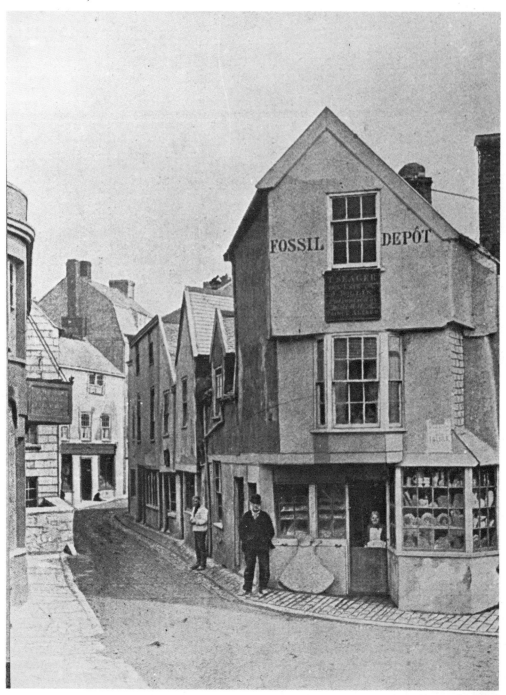

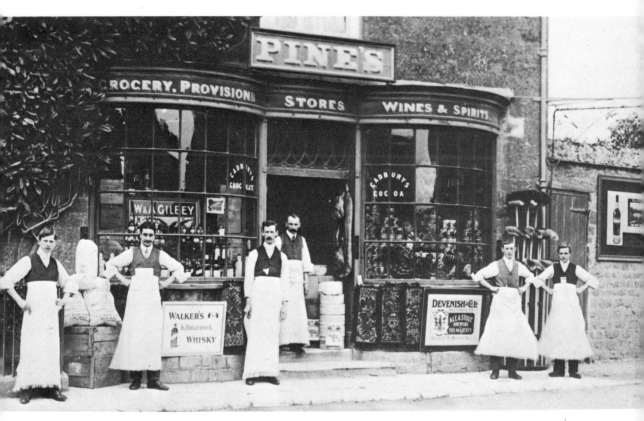

38 Thomas Pine's grocery stores in Fleet Street, Beaminster, *c.* 1910

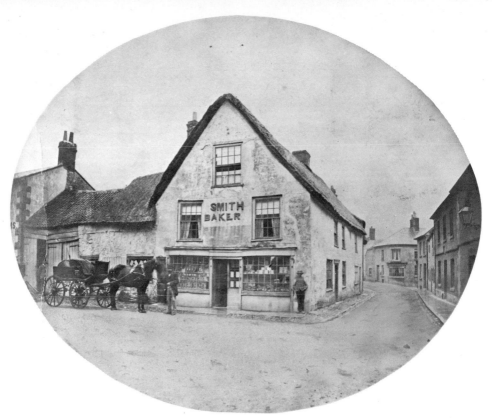

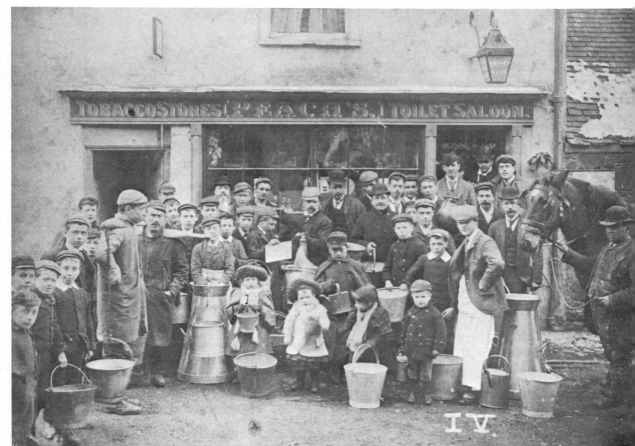

IV

39 *Left* William Smith's bakery in Parson's Pool, Shaftesbury, 1890

40 *Left, below* John Peach's hairdressing saloon in Salisbury Street, Shaftesbury. During the harsh winter of 1895, Mr Peach kept his neighbours supplied with water, his being the only tap in the street which had not frozen up

41 Tilley's cycle shop, Weymouth, 1895. There was another branch at Dorchester and it was Mr Tilley who taught Thomas Hardy to ride a bicycle

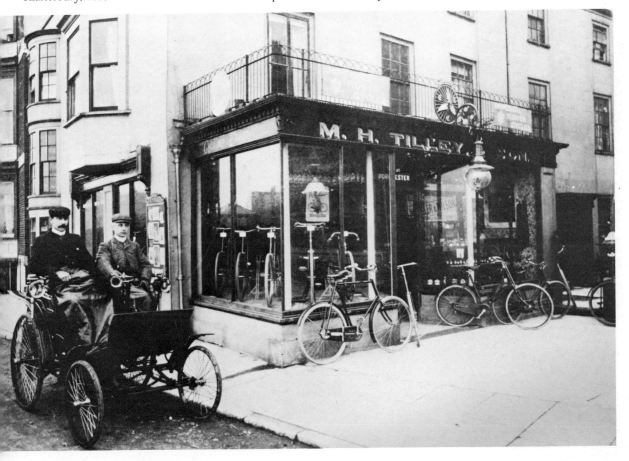

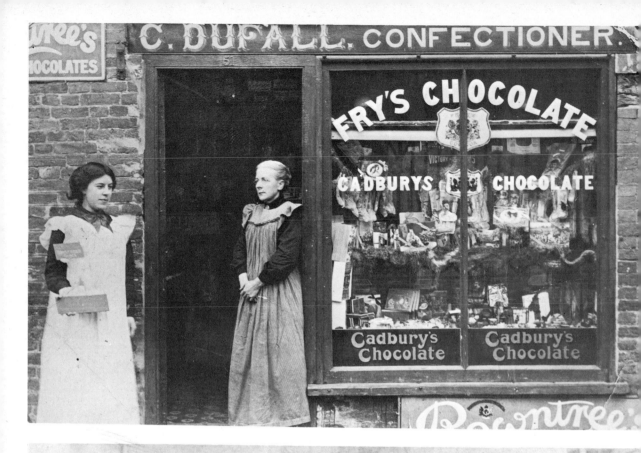

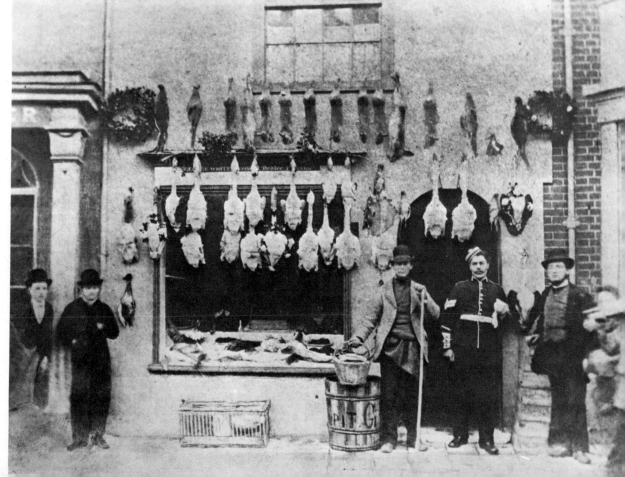

42 *Left* Charles Dufall's sweetshop in King Street, Wimborne, *c.* 1905

43 *Left below* George White, dealer in fish and game, Wimborne, *c.* 1870

44 Chissell and Son, butchers, Wimborne, *c.* 1890

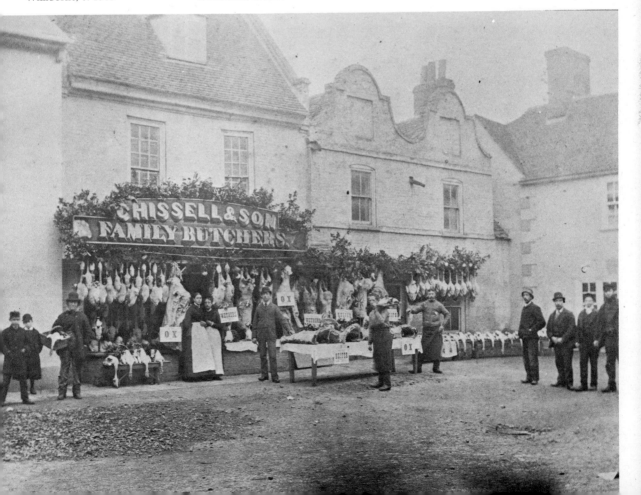

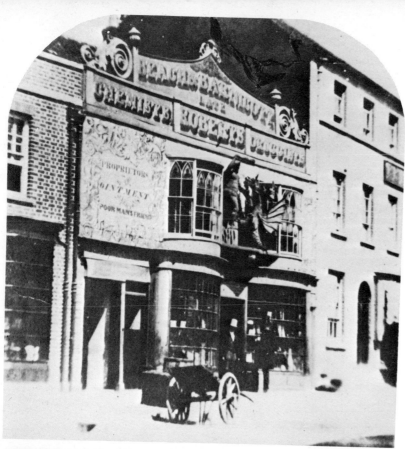

45 Beach and Barnicott, chemists of Bridport, c. 1865. The two top-hatted gentlemen standing in the doorway are presumably the proprietors. Their claims for 'The Poor Man's Friend' were certainly comprehensive: 'It is confidently recommended to the public as an unfailing remedy for wounds of every description, a certain cure for ulcerated sore legs (even if of twenty years' standing), cuts, burns, scalds, bruises, chilblains, scorbutic eruptions, and pimples on the face, sore and inflamed eyes, sore heads, cancerous humours, etc. Sold in pots, at 1s. 1½d., 2s. 9d., 11s., and 22s. each.'

46 Interior of Reynolds draper's shop in East Street, Bridport, c. 1905

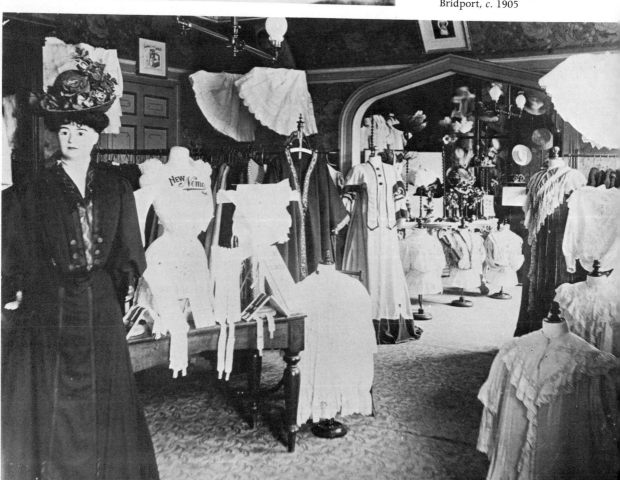

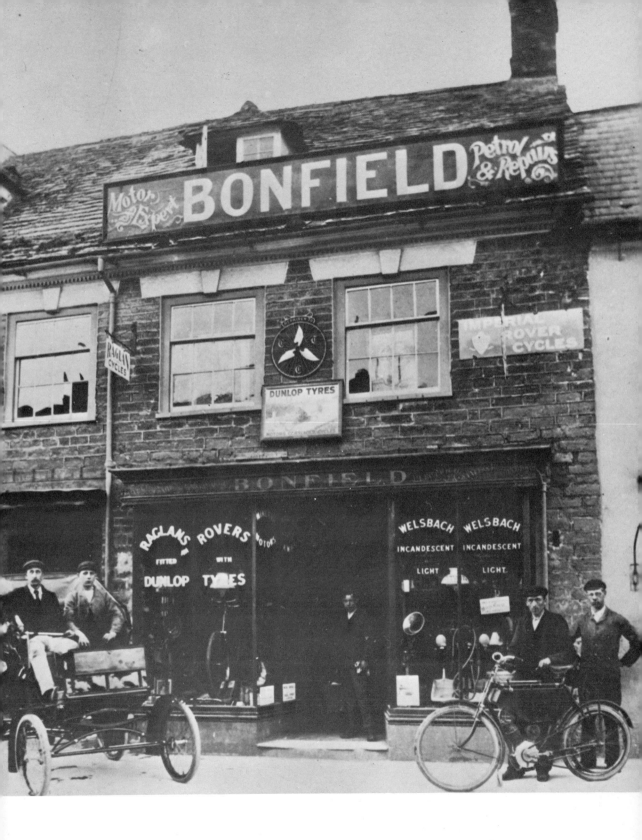

47 George Bonfield's shop in East Street, Bridport, *c.* 1905. Note the phonograph on display in the window; when they first appeared on the market they were sold from shops such as this one, where mechanics were available to repair them

ON THE LAND

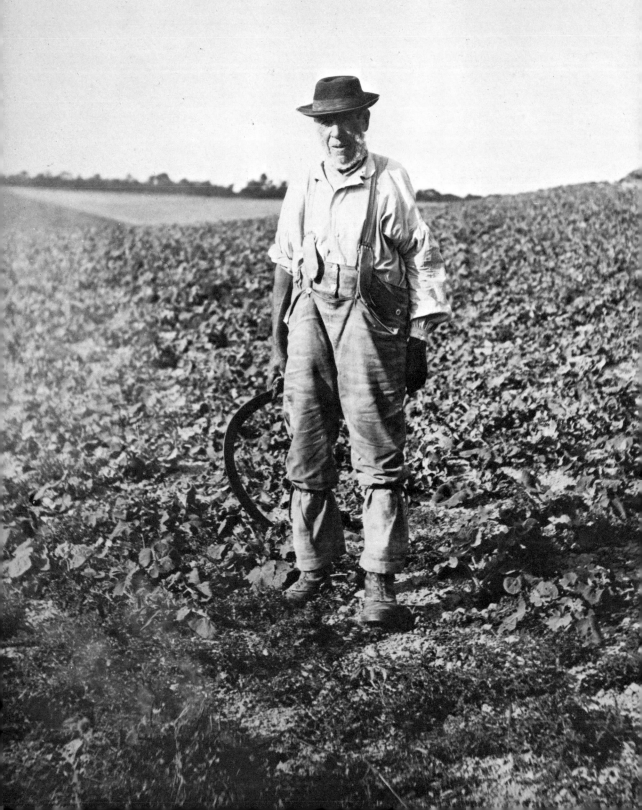

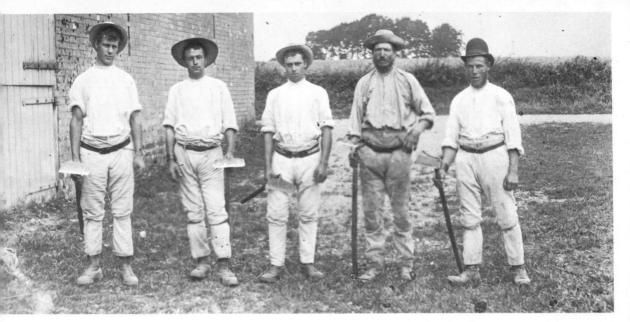

49 A team of turnip-hoers, *c.* 1890. The draw hoe used for thinning turnips had a short handle, forcing the labourer to bend low and keep a close eye on his work. The back-breaking nature of this task gives an ironic edge to the Dorset folk song – 'Turmut-hoing':

'Twas on a jolly summer's morn, the twenty-first of May,
Giles Scroggins took his turmut hoe, with which he trudged away;
For some delight in haymakin', and some they fancies mowin',
But of all the trades that I like best, give I the turmut-hoein'

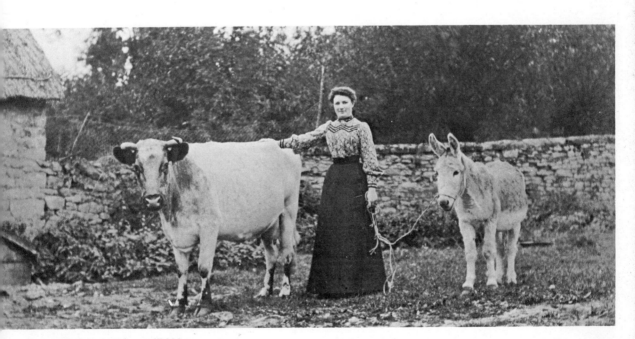

50 A Blackmore Vale smallholder

48 *Left* A Dorset labourer, *c.* 1900. The agricultural worker in Dorset had always been amongst the worst paid in the country. A wage of 11 shillings a week in 1880 (the average in the country was 14 shillings) had risen to 16 shillings by the First World War

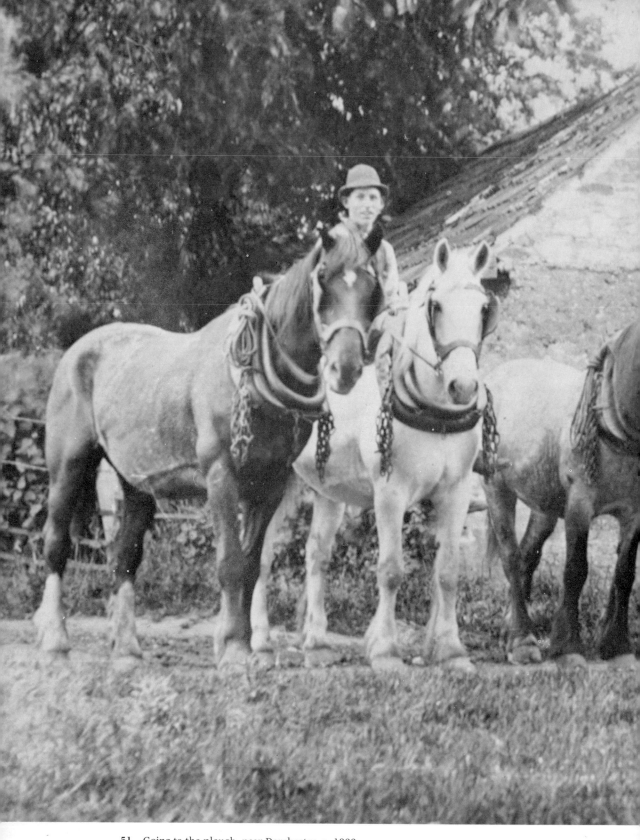

51 Going to the plough, near Dorchester, *c.* 1900

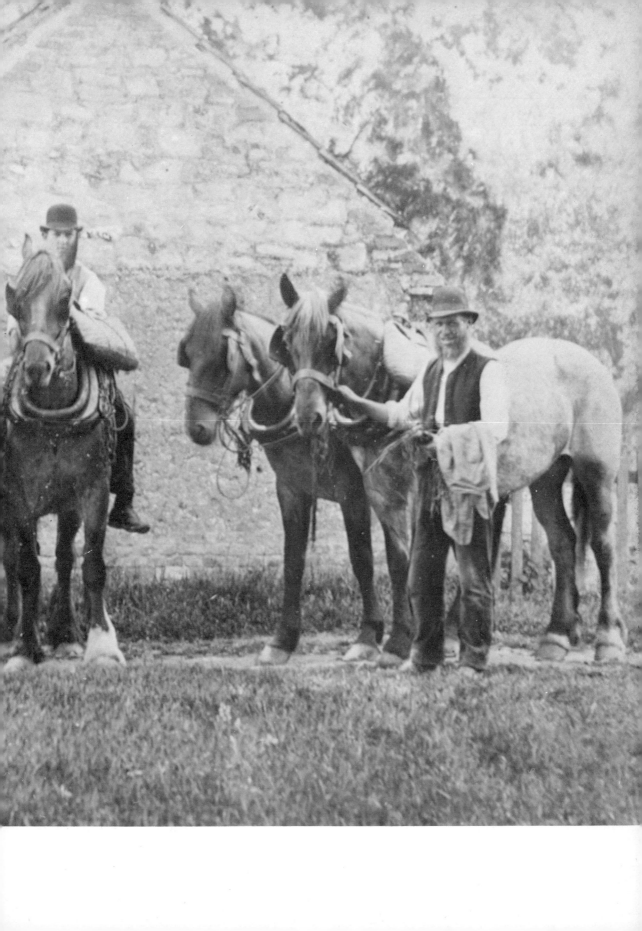

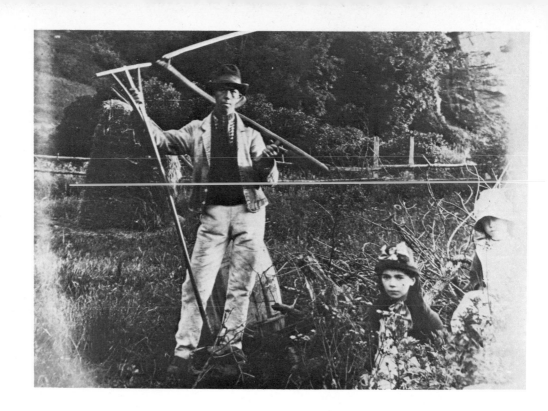

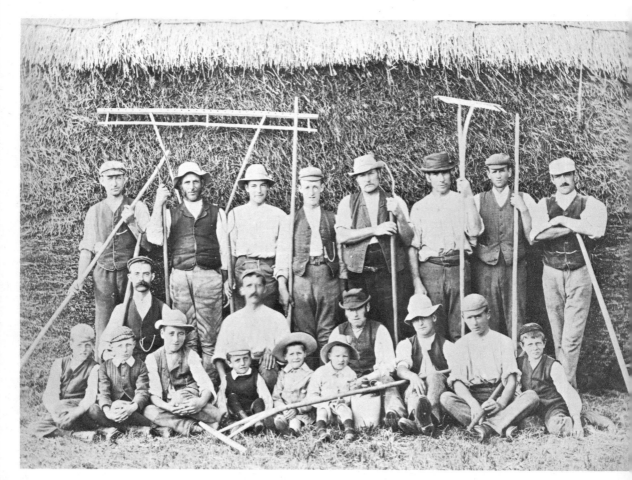

52 *Left* Haymaking, 1890

When we in mornen had a-drow'd
The grass or russlen' haÿ abrode,
The lit'some maïdens an' the chaps,
Wi' bits o' nunchens in their laps,
Did all zit down upon the knaps
 Up there, in under hedge, below
 The highest elem o' the row,
 Where we did keep our flagon.
from William Barnes, 'Where we did keep our flagon'

53 *Left, below* Haymaking at Compton Stud, Sandey, with Captain Adye, the owner, on the right

The ground is clear. There's nar a ear
 O' stannen corn a-left out now,
Vor win' to blow or raïn to drow;
 'Tis all up seäfe in barn or mow.
 Here's health to them that plough'd an' zow'd;
 Here's health to them that reap'd an' mow'd,
 An' them that had to pitch an' lwoad,
 Or tip the rick at Harvest Hwome.
from William Barnes, 'A Zong ov Harvest Hwome'

54 Haymaking at Newtown, Beaminster, *c.* 1900

The bwoy is at the hosse's head,
An' up upon the waggon bed
The lwoaders, strong o' eärm do stan',
At head, an' back at taïl, a man,
Wi' skill to build the lwoad upright
An' bind the vwolded corners tight;
An' at each zide o'm sprack an' strong,
A pitcher wi' his long-stemm'd prong,
Avore the best two women now
A-call'd to reäky after plough.
from William Barnes, 'Hay-carren'

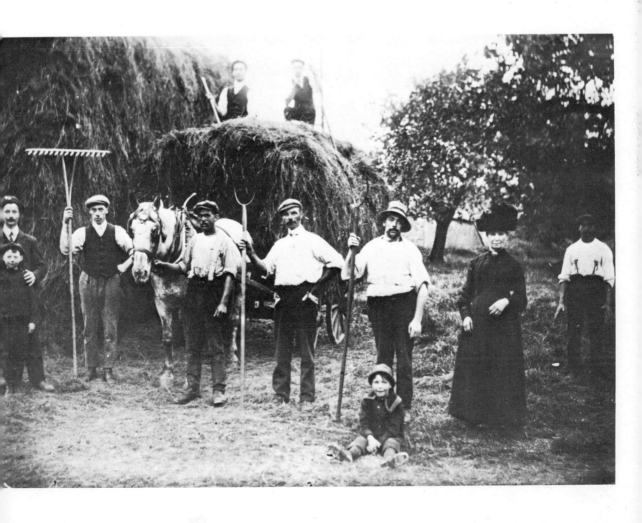

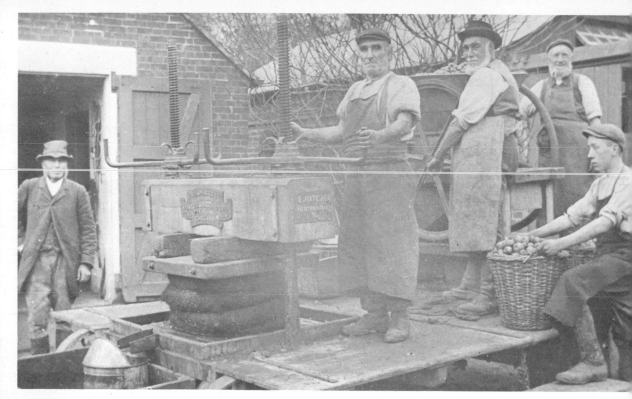

55 Cider making on a Hinton St Mary farm, *c.* 1900. The apples were first reduced to a pulp, known as pomace, in the mill on the right before being pressed, between mats of straw or horsehair, in the cider-wring on the left. The resulting liquid was then fermented in barrels; the residue, or 'cider cheese', being fed to the pigs

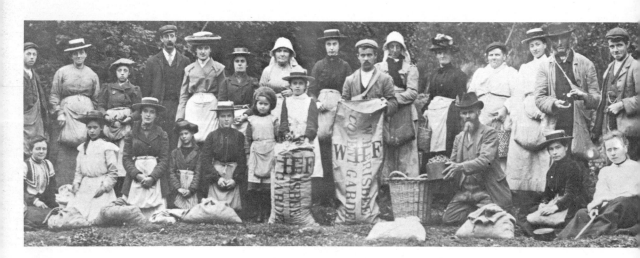

56 'Out a-nutten' near Ashmore, *c.* 1900. The autumn hazel-nut harvest was an important factor in the economy of the Cranborne Chase villages before the First World War, the crop being used chiefly in the dyeing industry

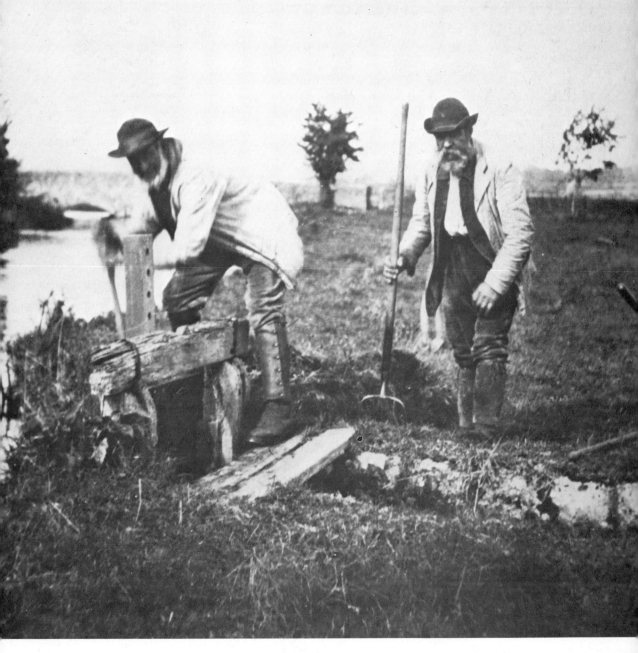

57 'Drowners' clearing out a channel prior to flooding a water meadow. The controlled flooding, during the winter months, of meadows bordering chalkland streams (using a system of hatches and channels) protected the land from frost and resulted in early grass for ewes and lambs the following Spring. At one time over 6000 acres of Dorset meadowland were maintained in this way

58 *Overleaf* Sheep dipping, *c.* 1900. About a week before shearing took place the sheep were washed to cleanse the fleece of accumulated dirt and insects

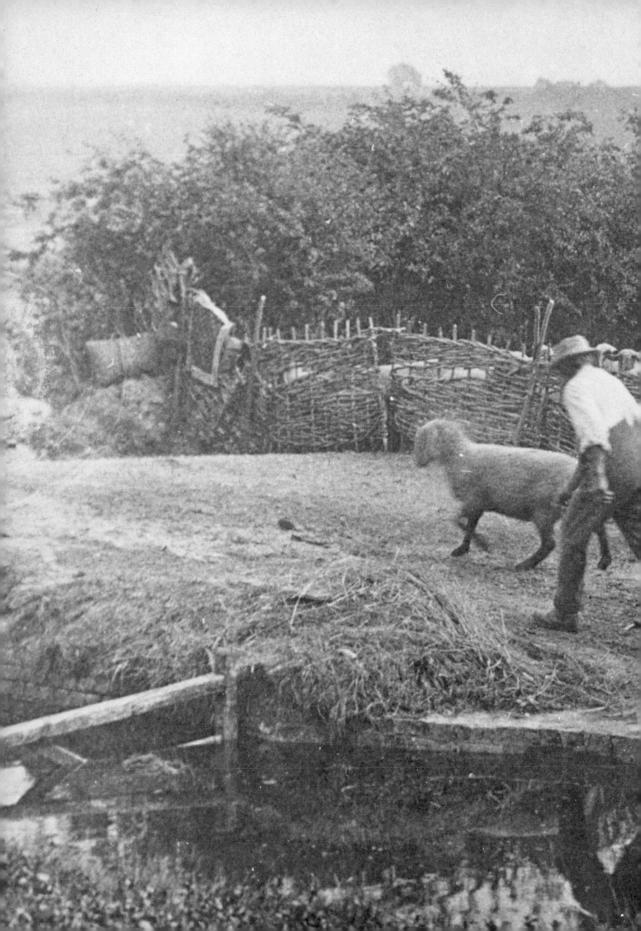

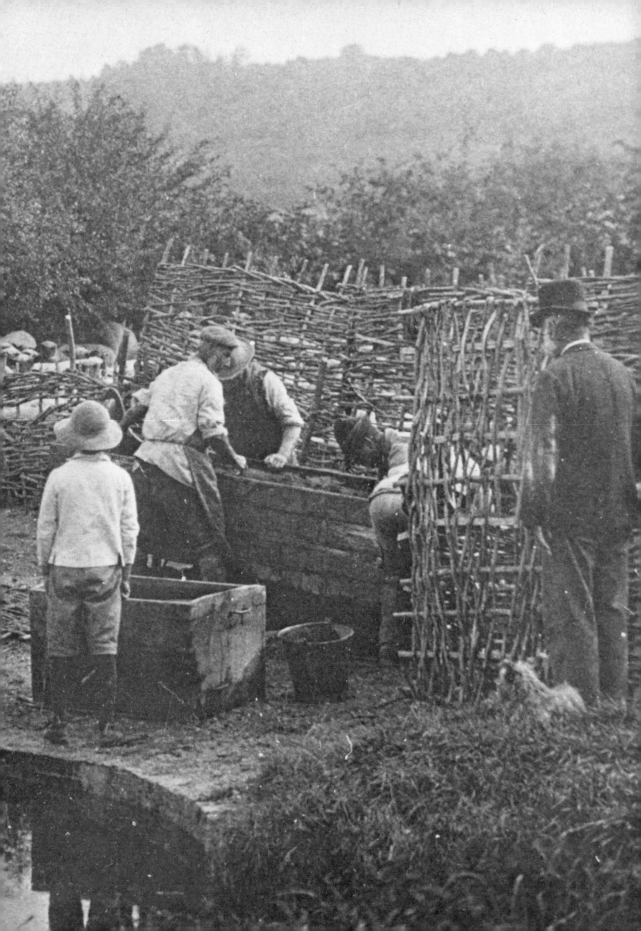

THE QUALITY

59 A house-party at Crichel, the seat of Lord Alington, 1909. Back row left to right: Mr O. Brirne, Mr Webber, Hon. P. Thelusson, Hon. Mrs George Keppel, Lord Farquhar, Countess of Gosford, Marquis de Soveral, Mrs Hawfa Williams, Earl de Grey, Sir A. Davidson. Front row left to right: Lady Noreen Bass, Lady Norreys, Princess Victoria, Lady Alington, King Edward VII, Queen Alexandra, Lord Alington, Countess de Grey, Colonel Holford, Hon. Lois Sturt, Dog Caesar

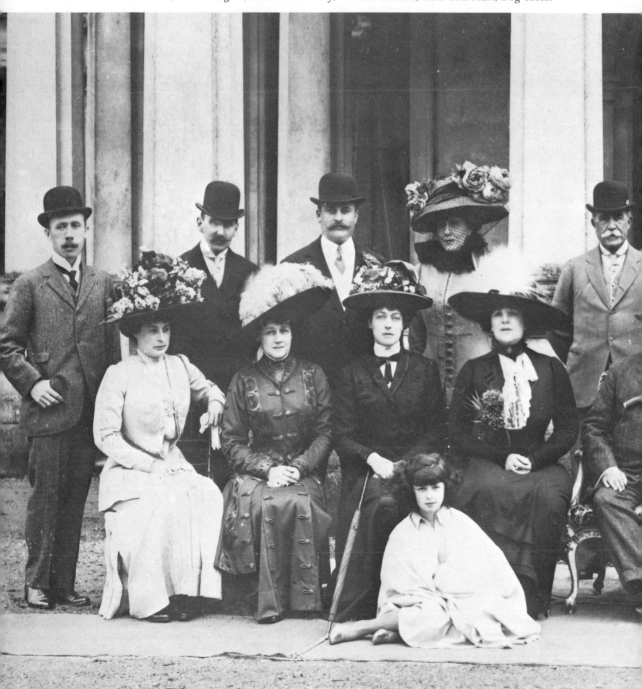

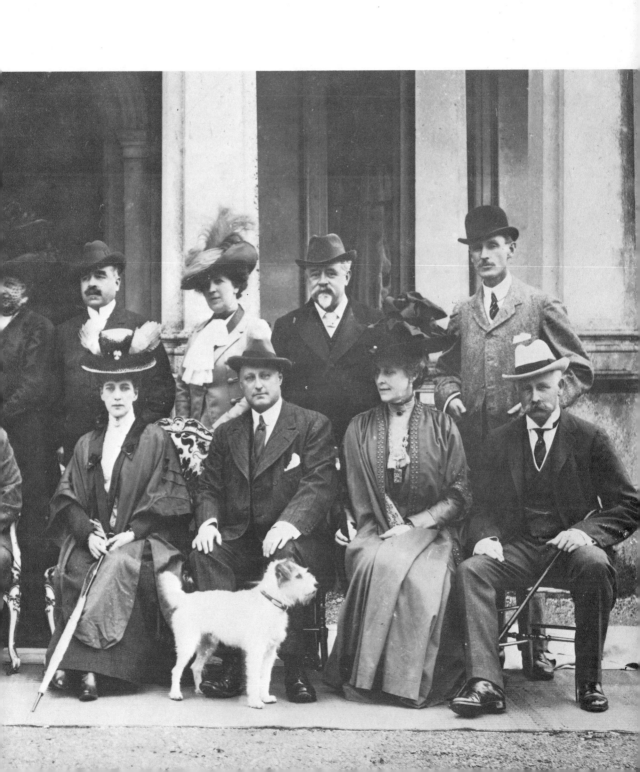

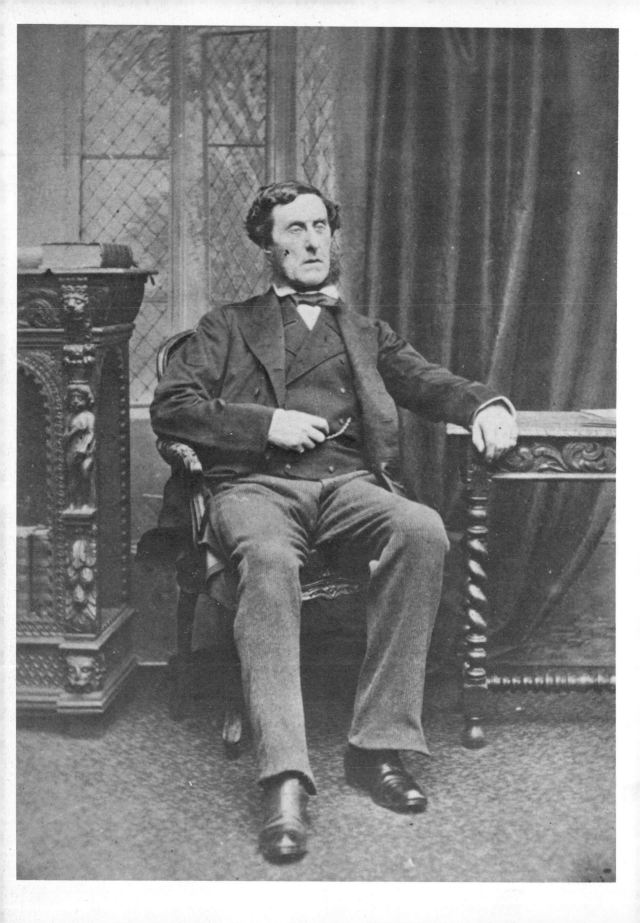

60 *Left* Anthony
Ashley-Cooper, 7th Earl of
Shaftesbury (1801–1885)

61 *Right* General Augustus
Lane-Fox Pitt-Rivers 1827–1900.
The innumerable archaeological
excavations which the General
carried out around
Cranborne Chase and the reports
he produced from them were,
for their time, models of
scientific method

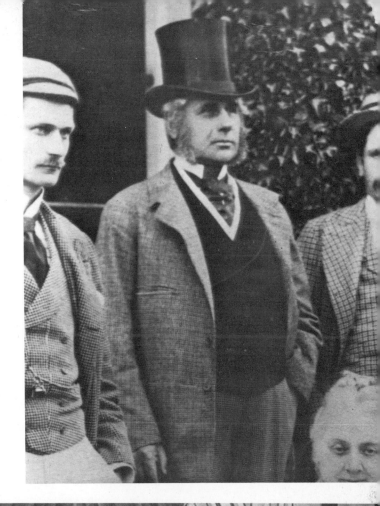

62 A scene from the
dramatised version of *Far from
the Madding Crowd*, performed
by the Hardy Players at
Dorchester, 1909

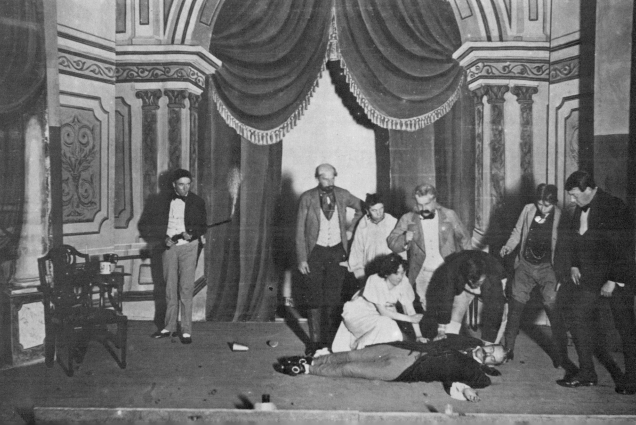

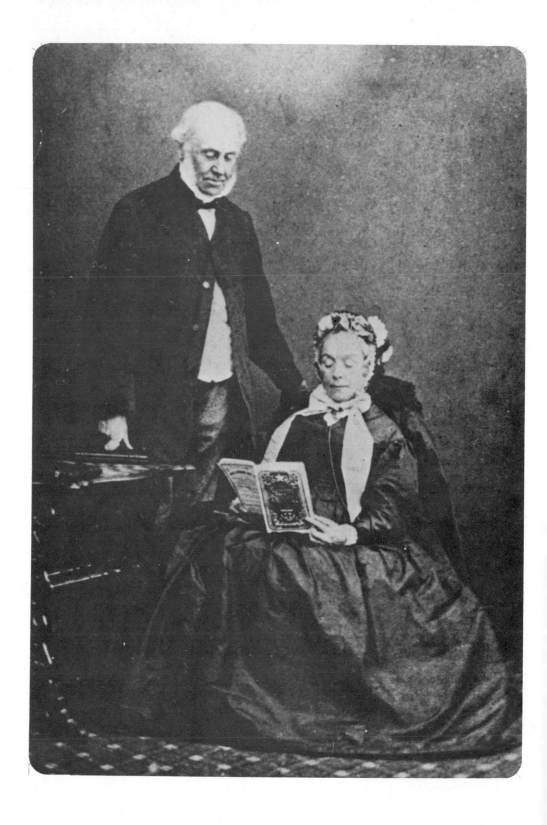

63 *Left* Mr and Mrs Frampton, reading *London Society*, Beaminster, *c*. 1865

64 *Right* Mrs Mary Cox of Manor House, Beaminster, *c*. 1880. Mrs Cox had the reputation of being a very generous woman

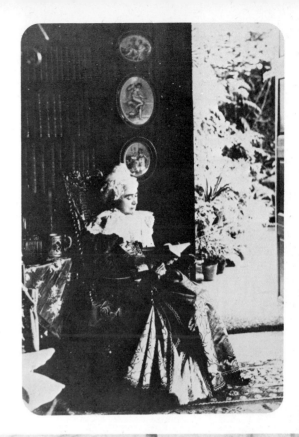

65 A Sunday School treat at Manor House, Beaminster, 1907

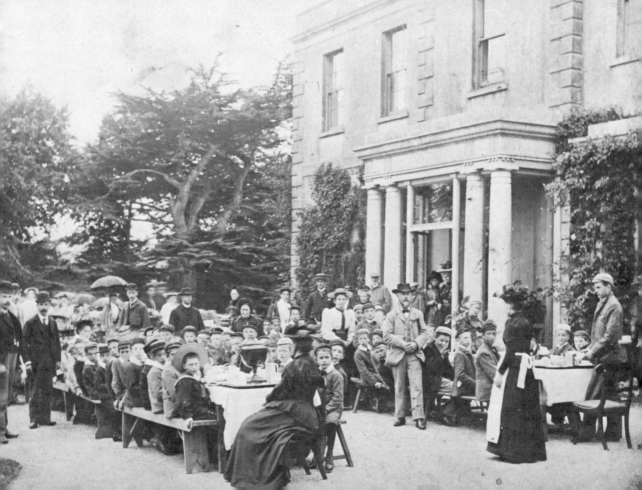

AT WORK

66 Sherborne fire brigade, 1904

67 *Right* A Puddletown shoemaker, *c.* 1890

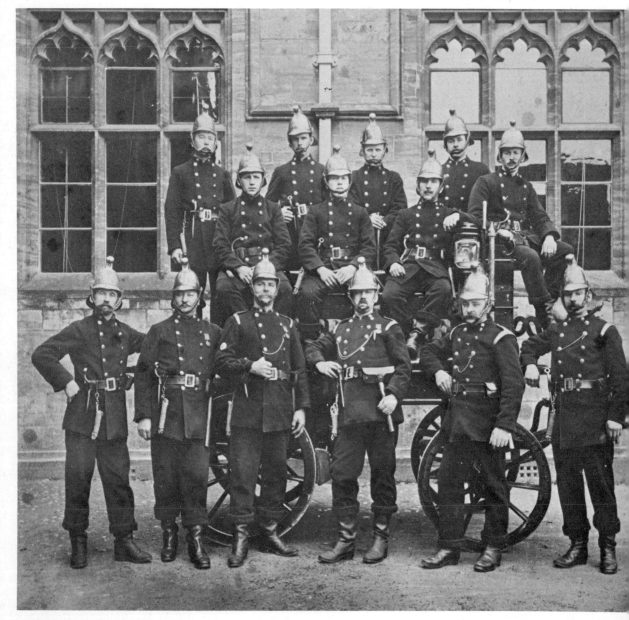

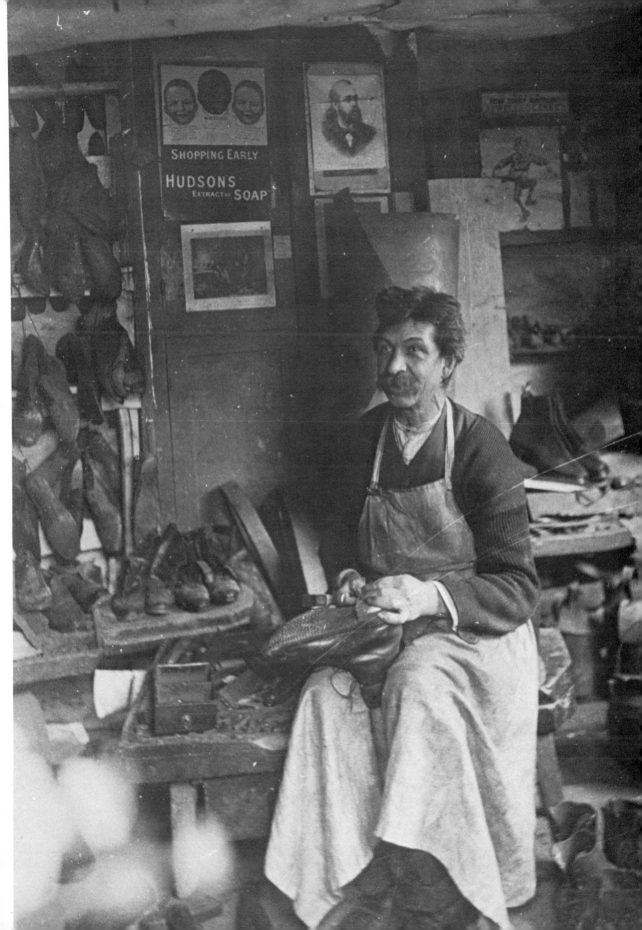

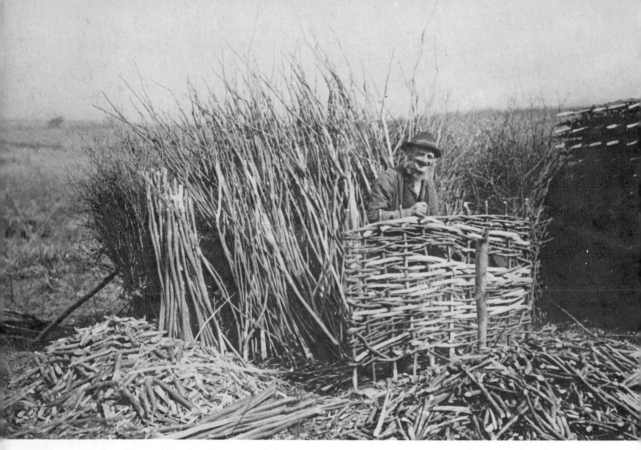

68 Hurdle-making, 1895. A skilled worker could produce up to eight hurdles in a day and they sold for six shillings a dozen

69 *Right* Robin Stone, an East Stour basket-maker, *c.* 1900. The village had a wide reputation for the quality of its baskets

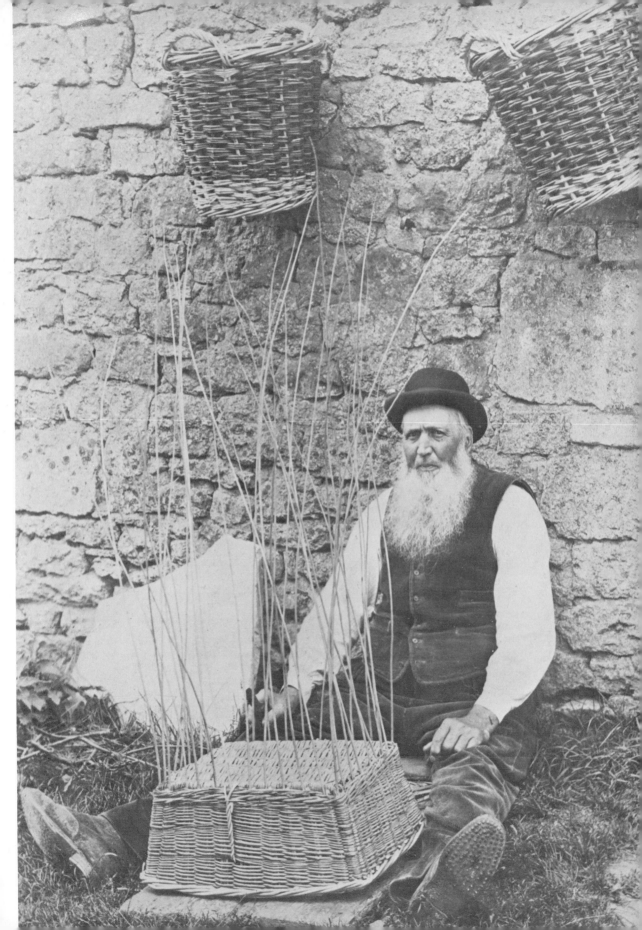

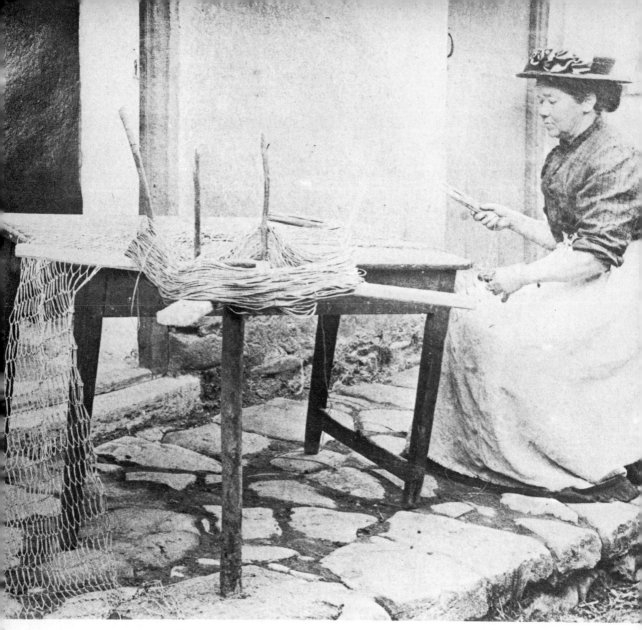

70 Priscilla Hodden of Eype
near Bridport braiding a net,
c. 1912. Such work is still
carried out on a cottage
industry basis

71 *Right, above* Beaminster
fire engine in operation at the
entrance to Fleet Street, *c.* 1900

72 *Right* Harry Beale,
fish merchant at Wimborne,
c. 1900. Mr Beale pushed his
cart up from Poole three times a
week, laden with fresh fish

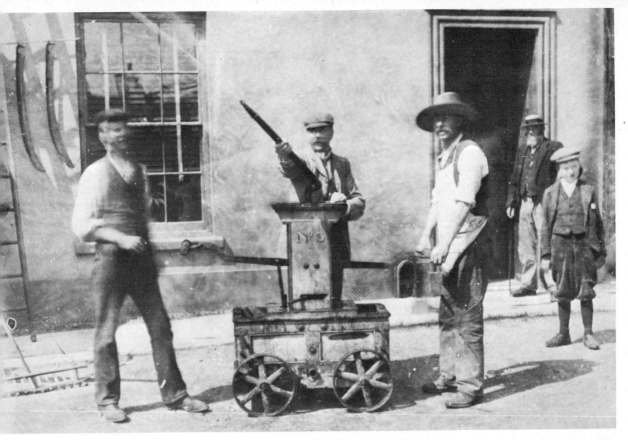

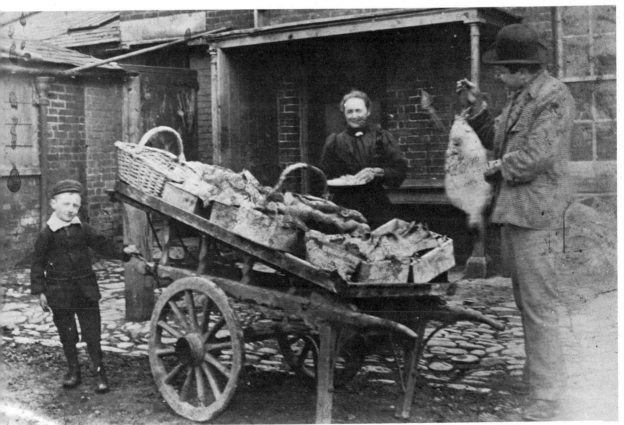

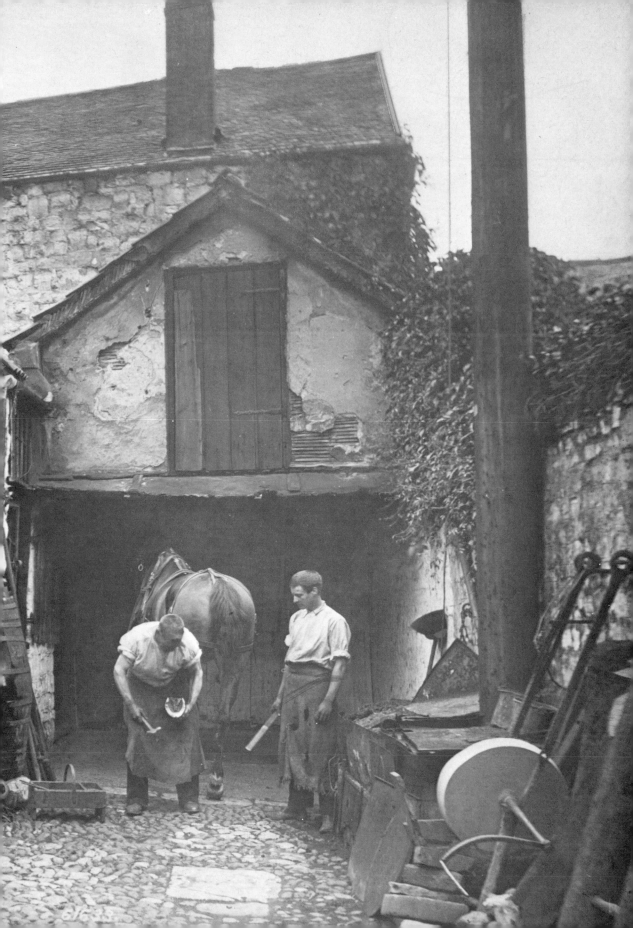

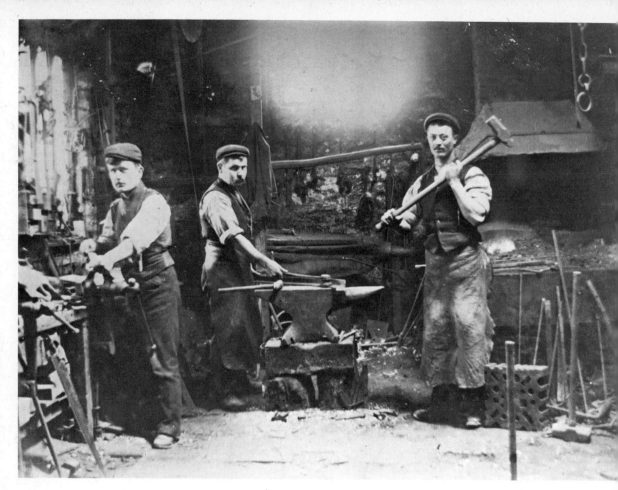

73 *Preceding page* Govier's Forge, Lyme Regis *c.* 1898. Samuel Govier is on the left

74 Interior of a Wimborne blacksmith's shop, *c.* 1890

75 *Right* Bonding a wheel at Charles Smith's blacksmith's shop in the High Street, Swanage, 1895. The proprietor looks on while Andrew Riggs sledgehammers the heated iron tyre on to the wheel which has been securely fixed to the tyring platform. Meanwhile, his assistant pours water from his can to cool the metal so that it will contract quickly and bind securely to the wooden wheel

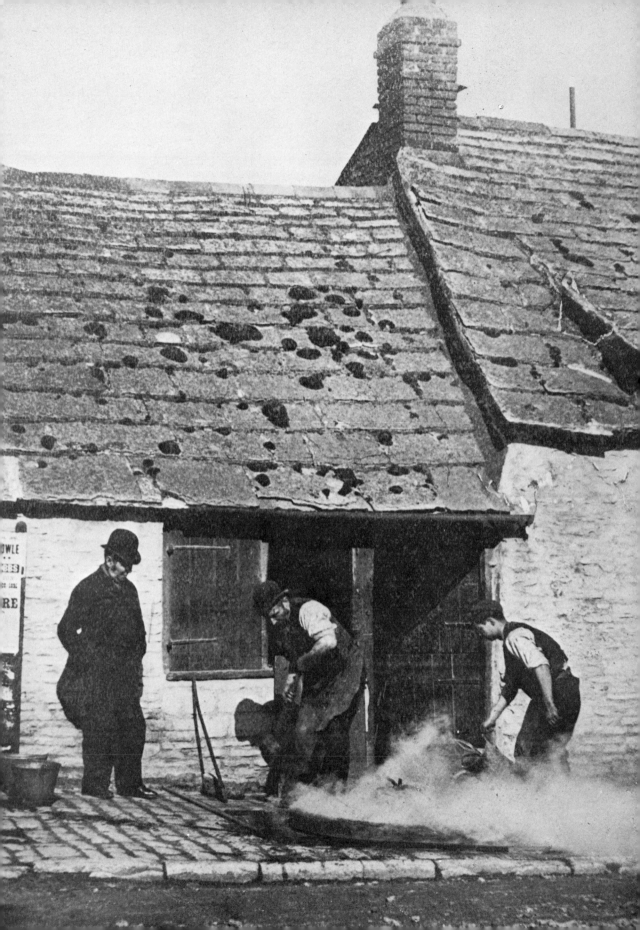

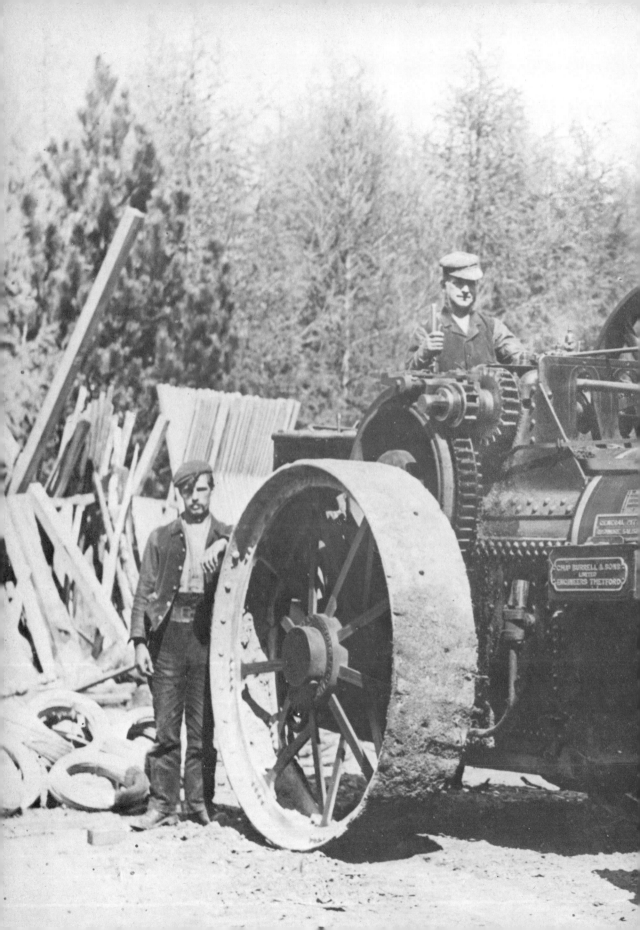

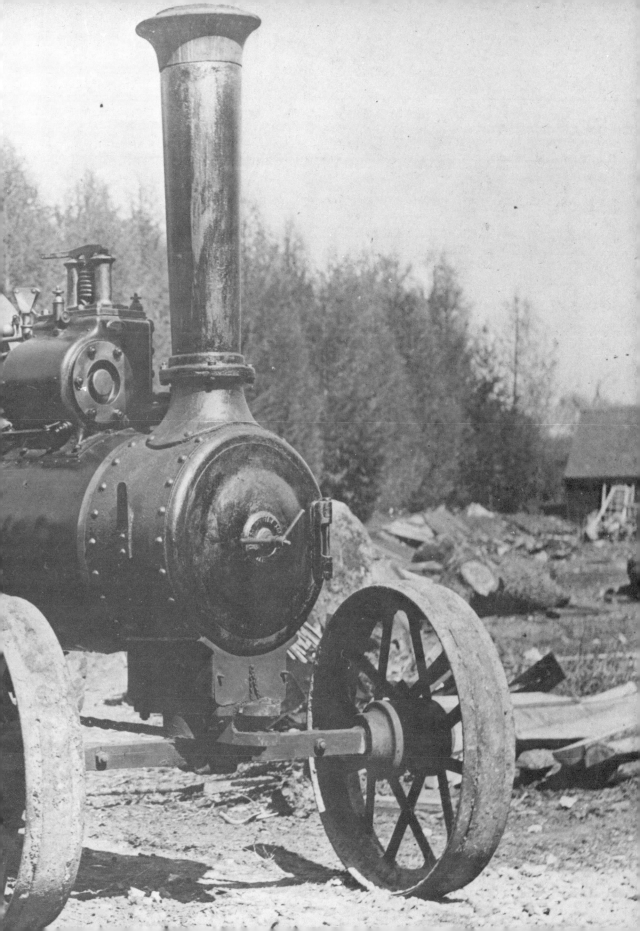

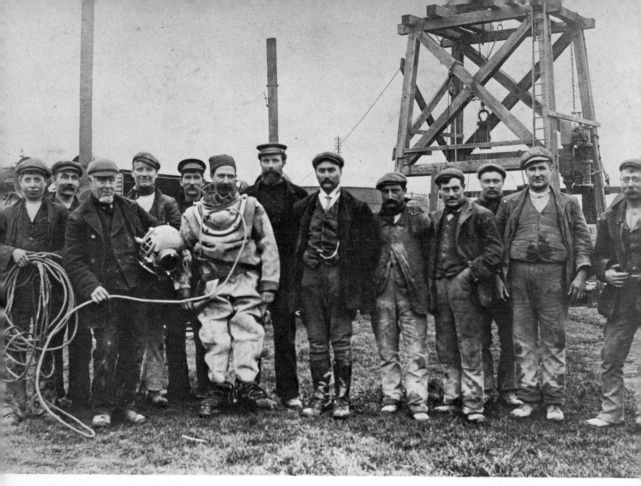

76 *Preceding page* Steam engine in the timber yard of General Pitt-Rivers' Rushmore estate, *c.* 1890

77 Construction of the pumping station at Corfe Mullen, part of the scheme for improving Poole's water supply commenced in 1907. A well, 173 feet deep with a yield of 2 million gallons per day, was sunk into the chalk. During its construction severe flooding of the workings took place and this may account for the presence of the diver

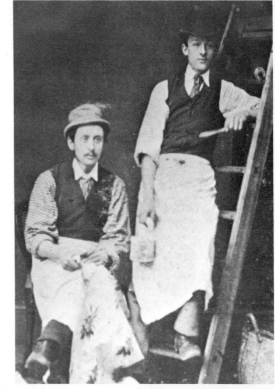

78 *Right* Two Sherborne house-painters of the 1880s

79 One of the bells being rehung at Sherborne Abbey, 1884

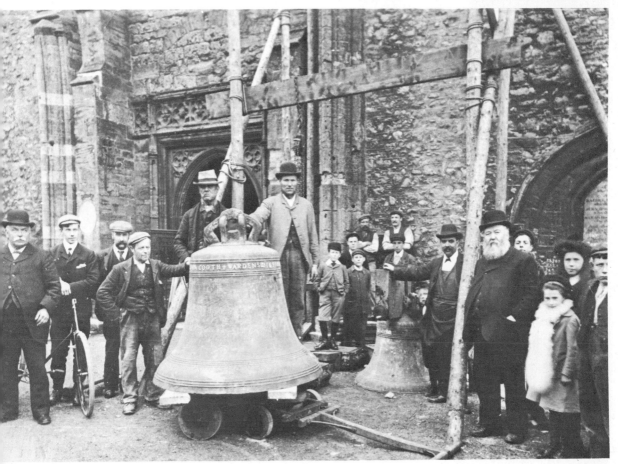

80 Portland stonemasons, *c.* 1909

81 *Right* Swanage stoneworkers, *c.* 1900

82 *Right, below* A crew of Portland quarrymen loading stone at Priory Corner on Merchant's Railway. Note the bottle of cold tea. *c.* 1900

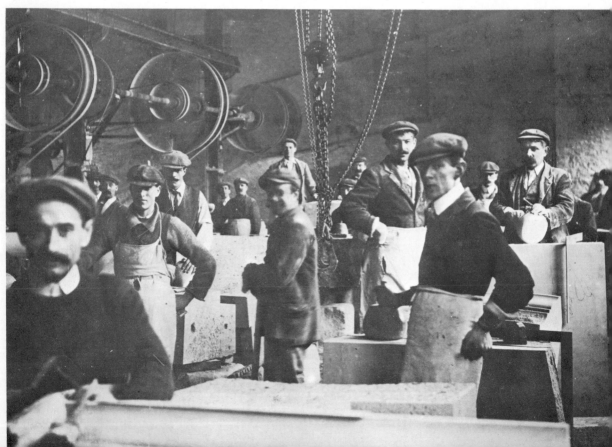

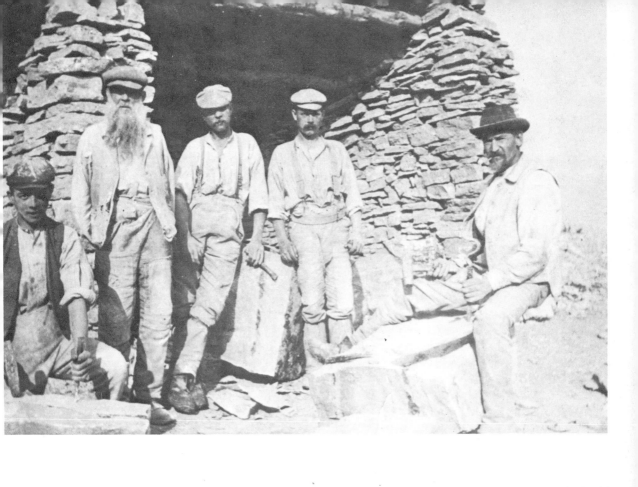

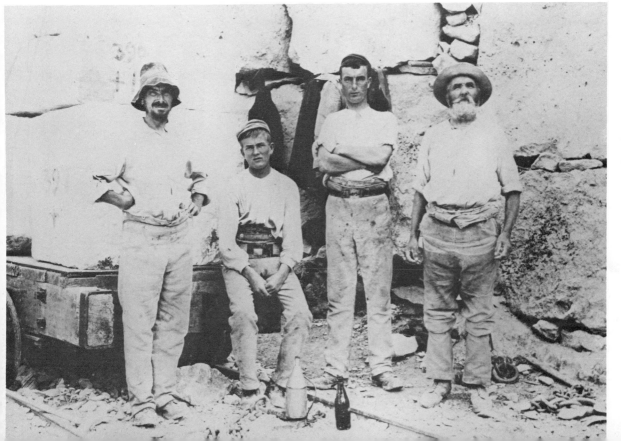

AT THE SEASIDE

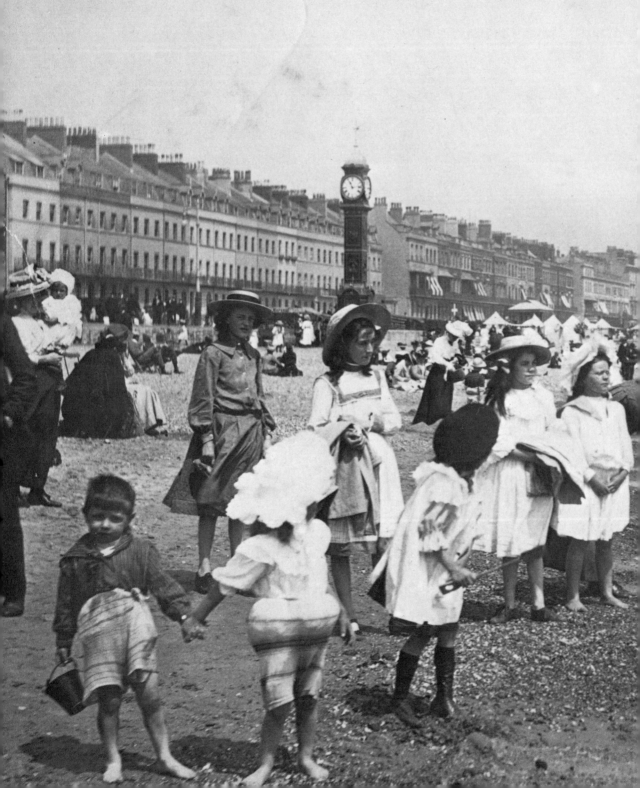

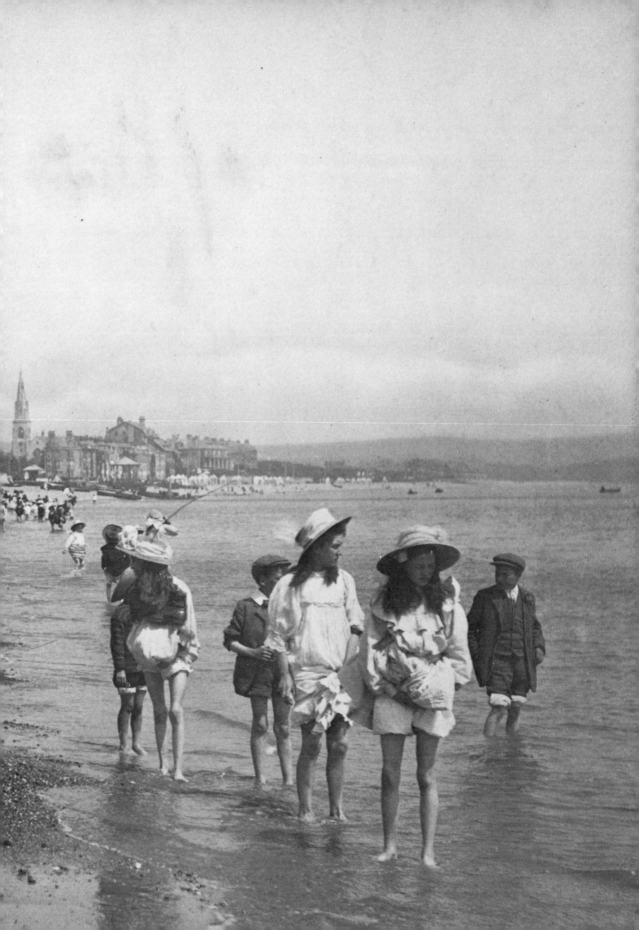

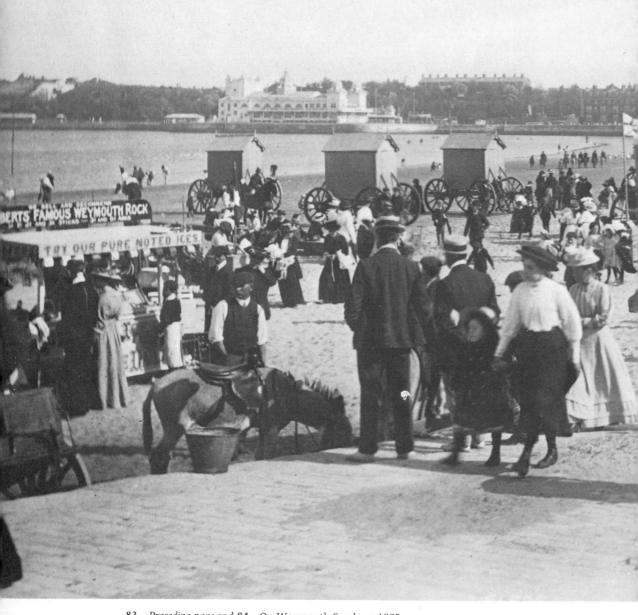

83 *Preceding page* and **84** On Weymouth Sands, *c*. 1905

85 *Right* Weymouth Pavilion Tea Rooms, *c*. 1910

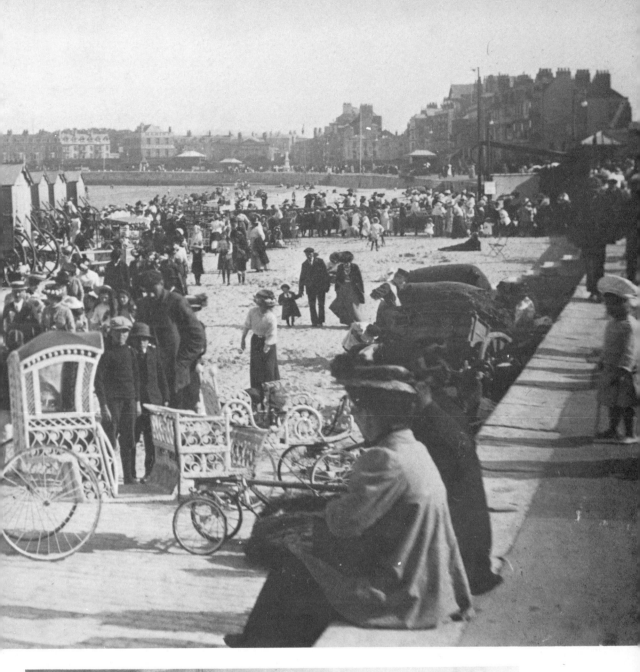

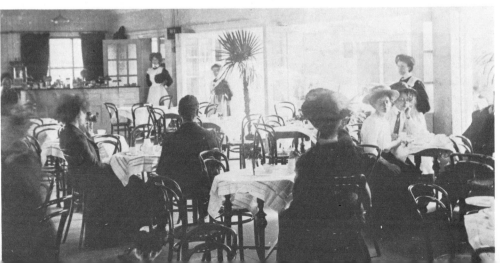

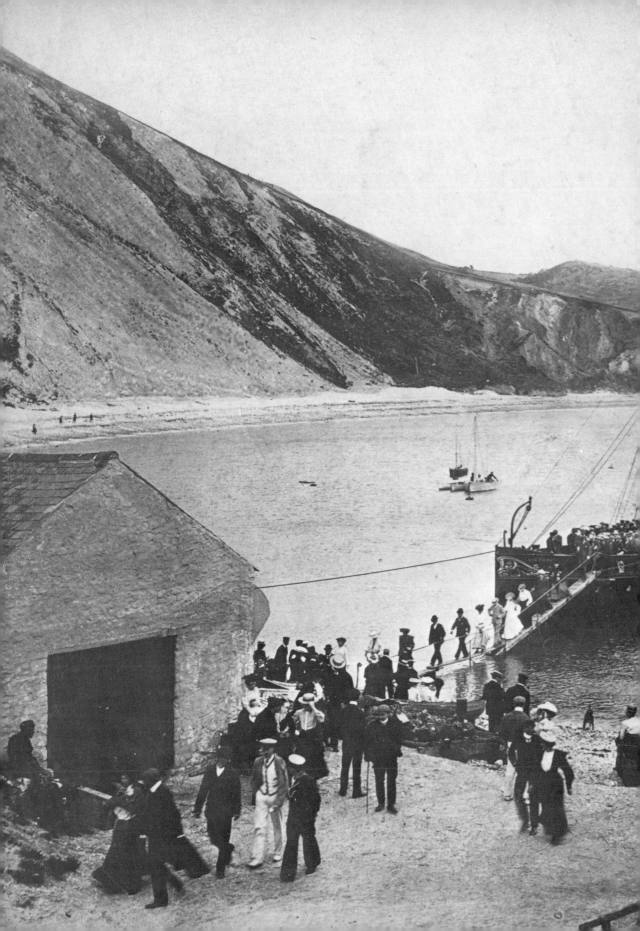

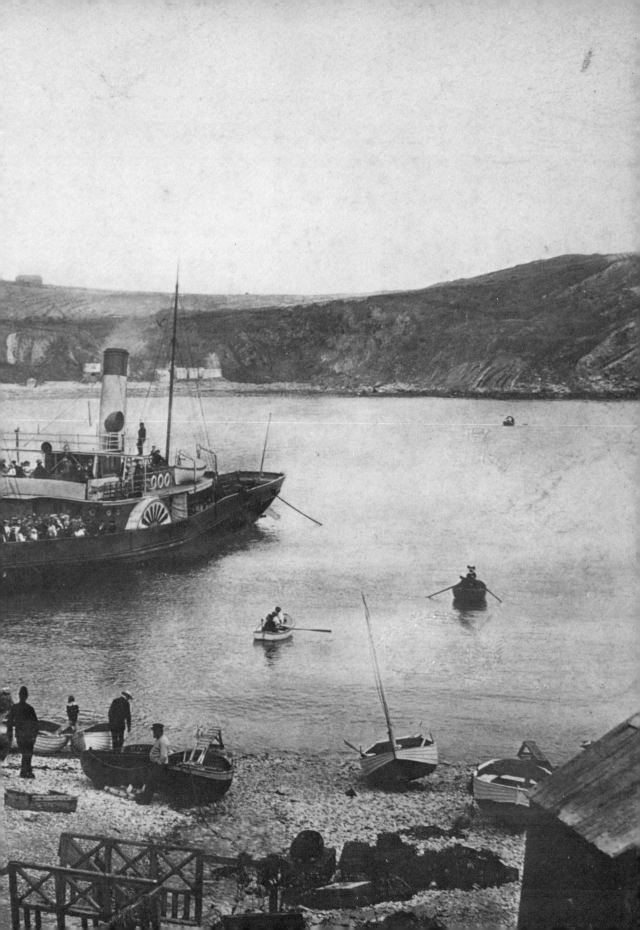

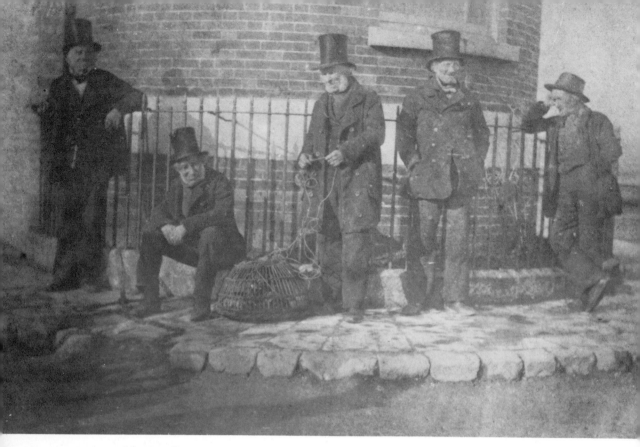

86 *Preceding page* Day trippers from Weymouth disembarking from the paddle steamer *Victoria* at Lulworth Cove in 1899. *Victoria*, built in 1884 and owned by the Weymouth, Bournemouth & Swanage Steam Packet Ltd, had specially strengthened bows to enable her to run onto the beach. After a chequered career she was finally scrapped in 1953

87 Fishermen at Weymouth, *c.* 1860

88 *Right, above* Bathing machines at Swanage, *c.* 1895. Increasingly popular as a seaside resort, the town was undergoing rapid development at the turn of the century – not entirely for the better in the eyes of Sir Frederick Treves: 'The curve of the sandy bay is swept by a long brick coal-shed, and is palisaded by the unlovely backs of unashamed houses. It only needs a gasometer on the beach to complete the sorry *renaissance.*'

89 *Right* Mending nets outside the Cove Inn, Chesilton, *c.* 1900

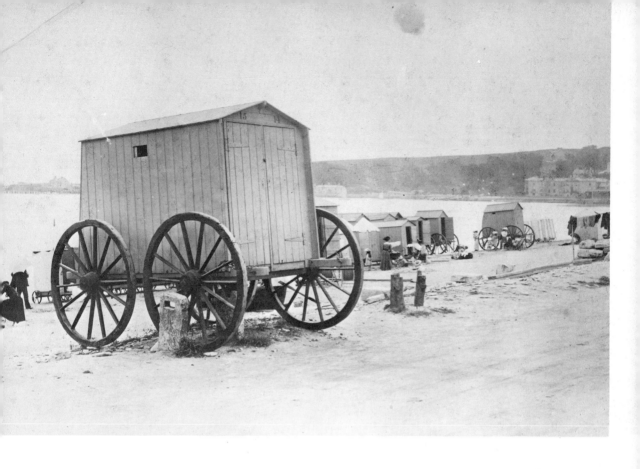

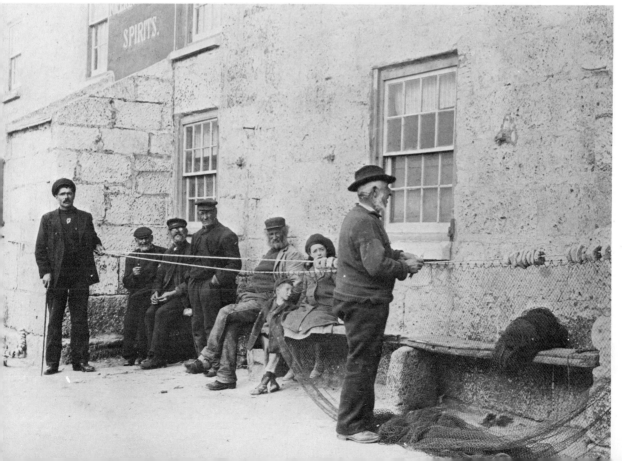

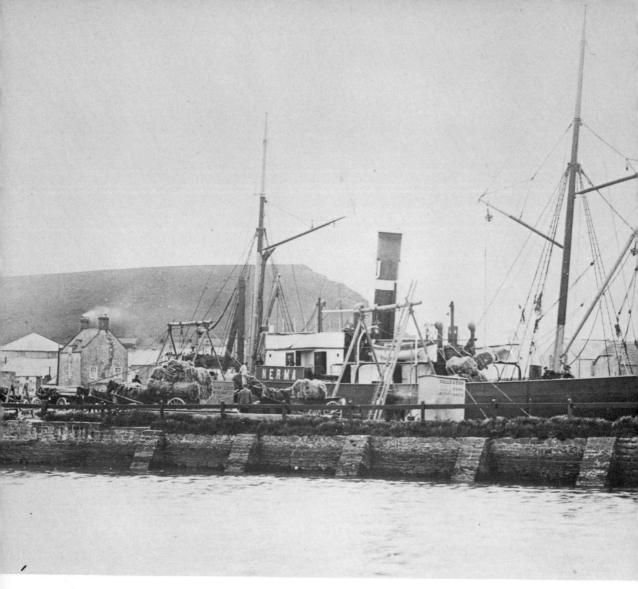

90 Unloading Russian hemp from Riga at West Bay for the Bridport rope industry, 1908

91 *Right, top* Poole harbour,
c. 1890: '. . . the craft that
make for the haven of Poole
belong to that vanishing fleet
about which clings the last of
the real romance of the sea.
Here is the old-world sailing
ship, the barque from Norway
with a stair leading to her railed
poop, the lumbering brig from
the North, the piratical-looking
topsail schooner, the jovial
ketch, the brigantine.' (Sir
Frederick Treves)

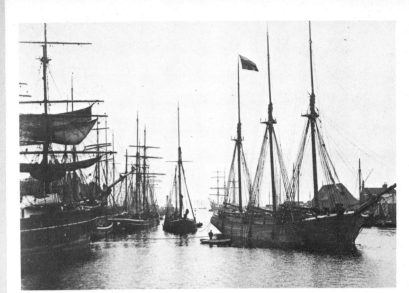

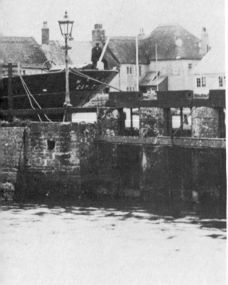

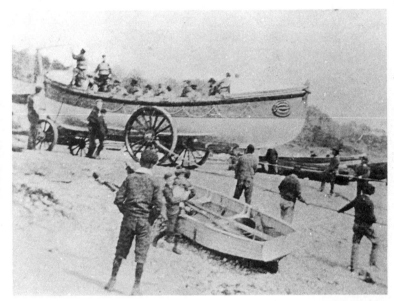

92 *Right, centre* Launching the lifeboat at Lyme Regis

93 *Right, below* Church Hope Cove, Portland *c.* 1900. For many Portland quarrymen, fishing was a secondary occupation carried out on Summer evenings and Saturdays. As in this picture, it was often the occasion for a family outing. Note the Portland crab pots, made of iron

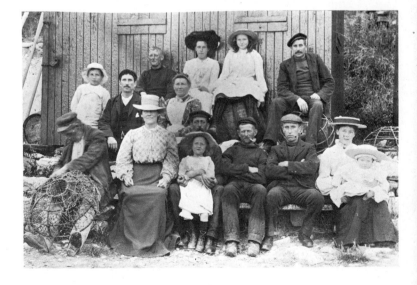

GETTING ABOUT

94 A carter's wagon at Maiden Newton in 1905

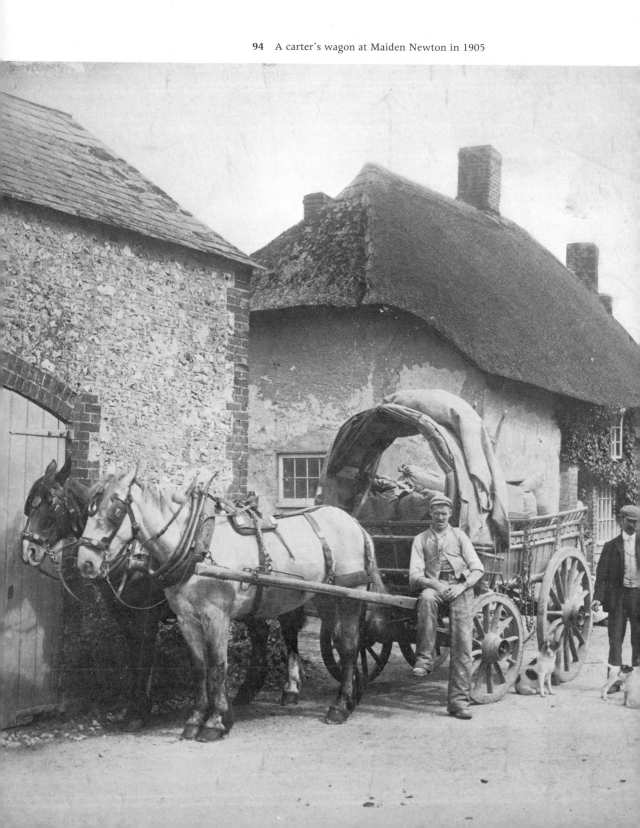

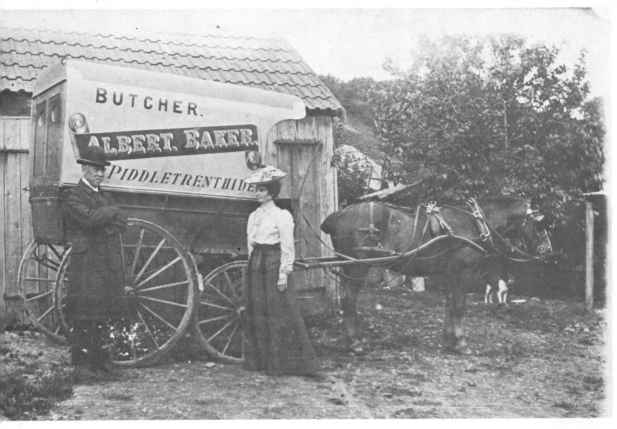

95 Albert Baker, grocer and pork butcher of Piddletrenthide, *c.* 1900

96 The delivery van of Dan Roberts, baker and confectioner of West Street, Bridport, *c.* 1910

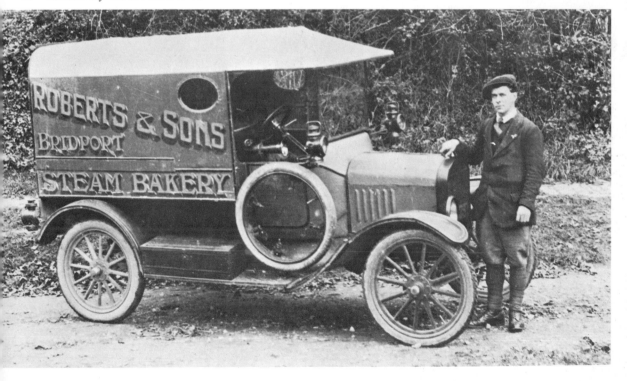

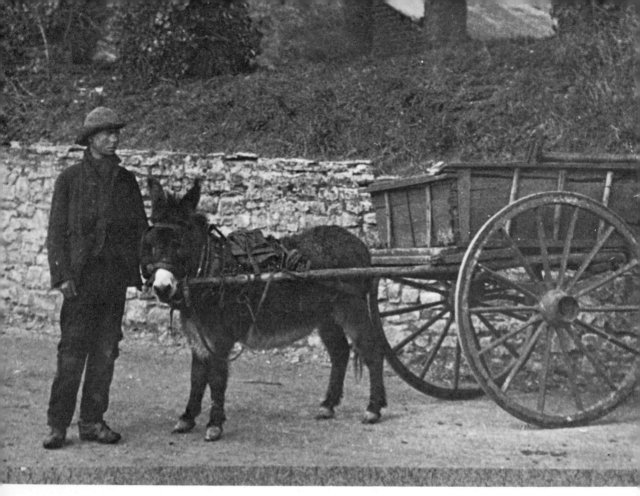

97 A farm boy, *c.* 1895.

I be the work buoy o' the farm,
 I be so proud out any where:
To git a hoss whip in my yarm,
 As ef I carr'd a sceptre there.

I be a huff'd, an' zent about
 By âl the mâidens drough the mud;
An' zometimes I da git a clout
 In head; an zometimes milk an' crud.
from William Barnes, 'The work buoy o' the farm'

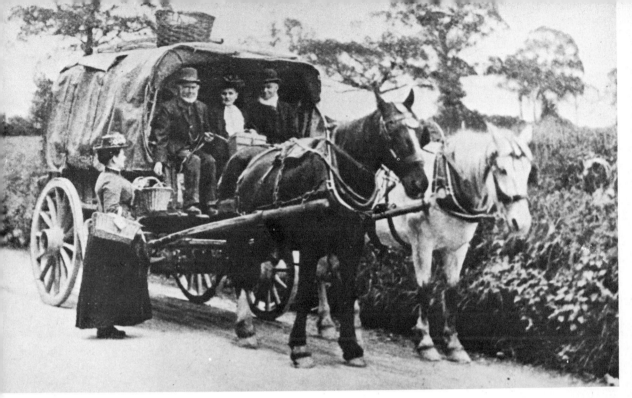

98 Carrier's wagon, c. 1890. For many isolated villages, the carrier was virtually the only link with the outside world, conveying passengers and goods to the nearest town, carrying out commissions (buying a new oil-lamp, taking a clock for repair or a goose to market) and passing on all the local news. It was often the secondary occupation of a local farmer or shopkeeper who, travelling regularly to market, added to his income in this way

99 Holiday-makers setting out from Wimborne, c. 1890

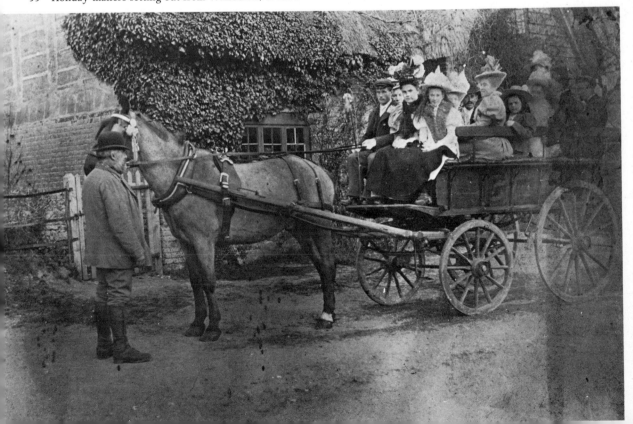

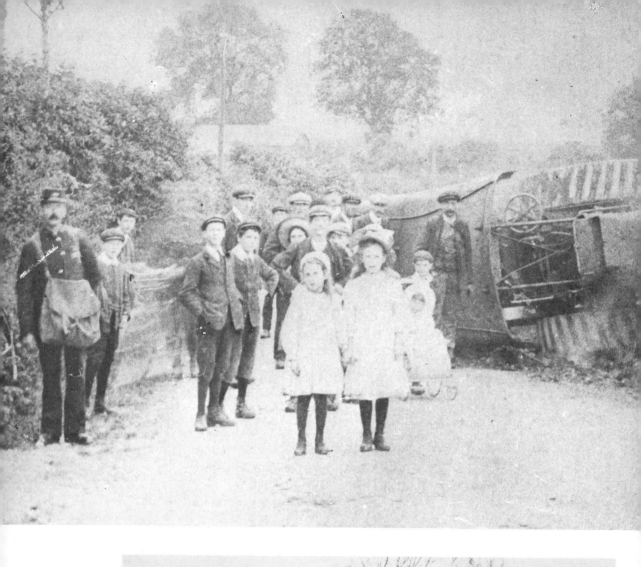

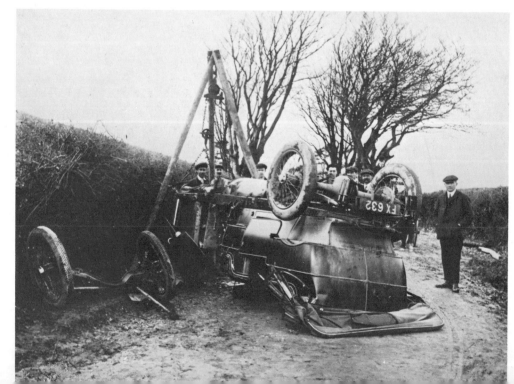

100 Traction engine accident at Cann near Shaftesbury, *c.* 1900. Bill Imber, the postman, has stopped on his rounds

101 *Left, below* Accident at Four Beeches near Beaminster, 1906

102 *Below* Setting out for the Larmer Grounds from the Phoenix Hotel, Gillingham, *c.* 1880 – driver 'Woodpecker' Maidment. An outing to the Larmer Grounds – a pleasure garden, complete with bandstand, open-air theatre and menagerie, laid out by General Pitt-Rivers in the midst of his Cranborne Chase estate – was a popular choice among North Dorset holiday-makers

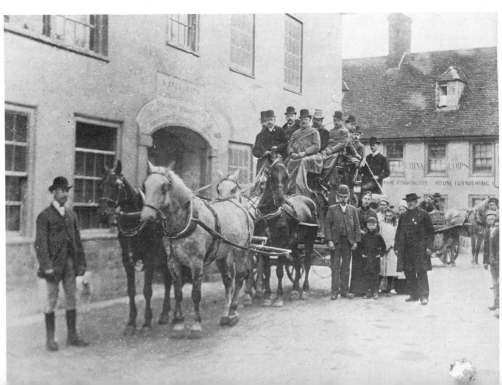

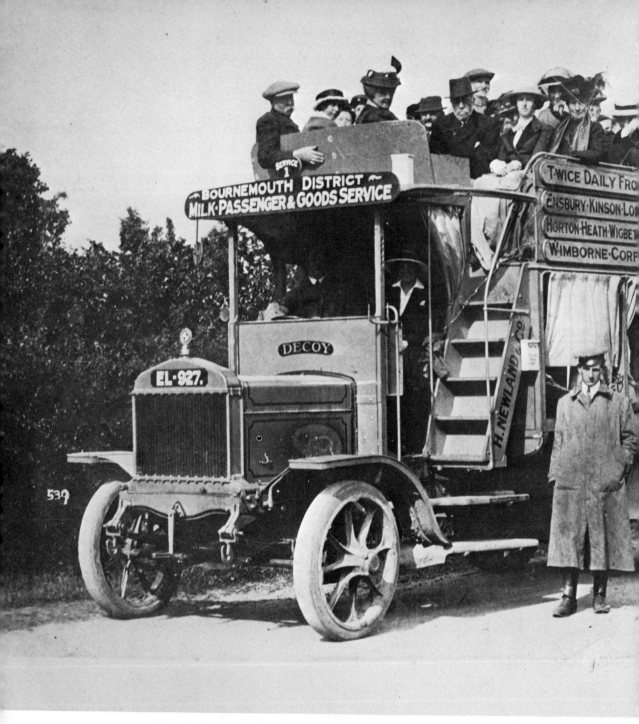

103 Combined omnibus and carrier service, *c.* 1910

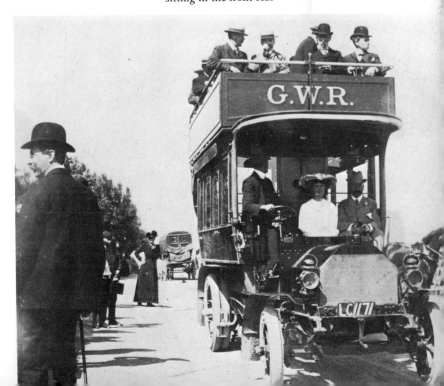

104 Opening of the Great Western Railway bus service at Weymouth, 1 May 1905. The Mayoress, Miss Templeman, is sitting in the front seat

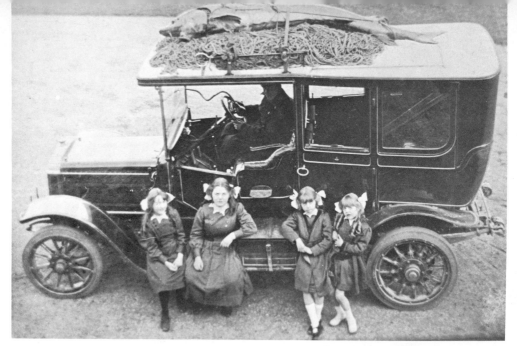

105 The fish is a sturgeon, but how it came to find itself atop this rather grand limousine at Wareham is unrecorded

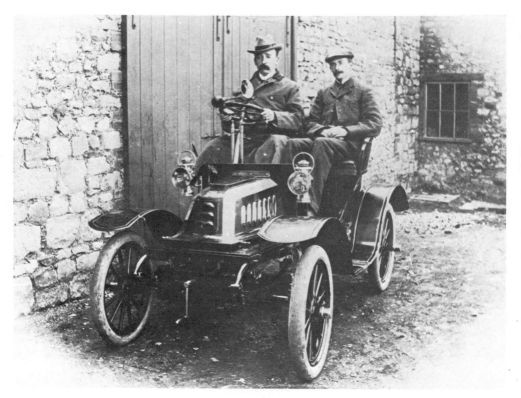

106 Mr Wallace and Spike Hardy with the first motor car in Lyme Regis, a De Dion Bouton of 1902

107 *Right* Annie Sharp, Marnhull postwoman, 1914

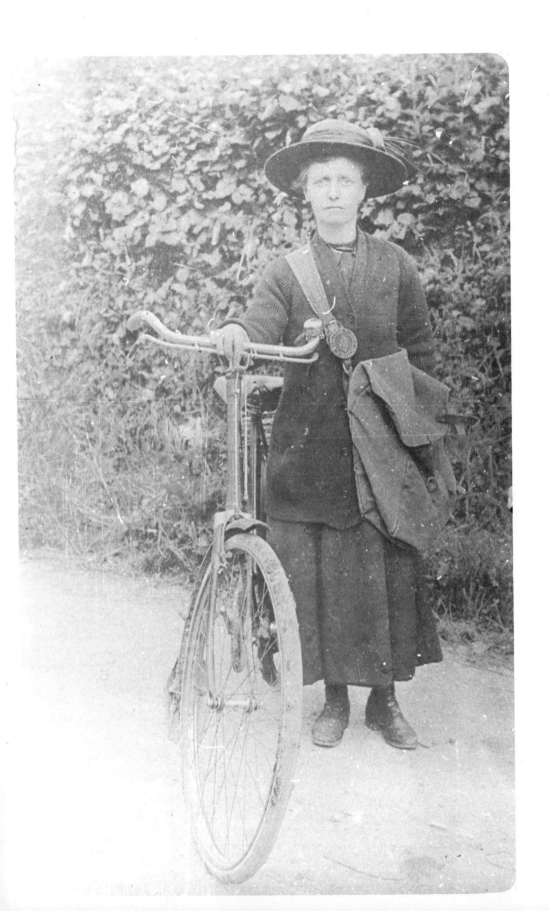

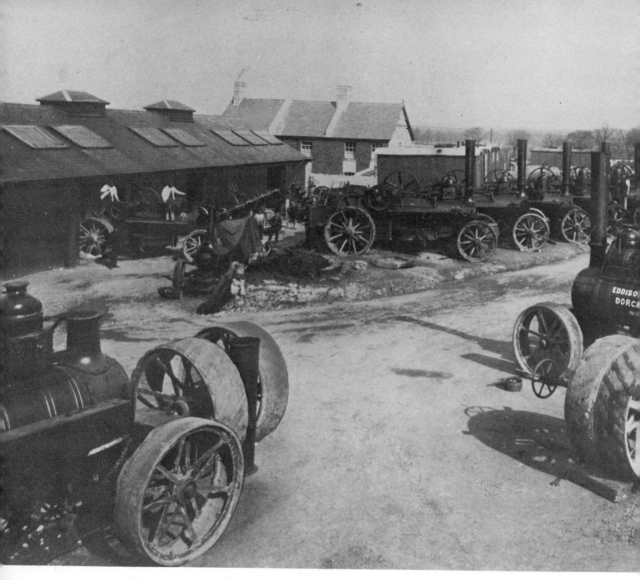

108 The Dorchester Steam Plough Works, Fordington, *c.* 1885. Ten sets of single cylinder ploughers may be seen, together with the 3 horse-power Fowler 'Jeanette' of 1878 (right of centre) and a 6 horse-power Fowler engine (left of centre), both used for haulage and threshing

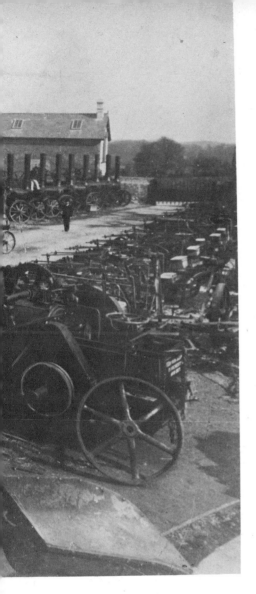

109 One of three 8 horse-power Fowler compound road locomotives, built in the 1890s and used for general haulage work as well as for supplying the Eddison Company's other engines with coal and stores and in recovery work. The locomotive in the picture is engaged on flour haulage, probably from the East Mill at Dorchester

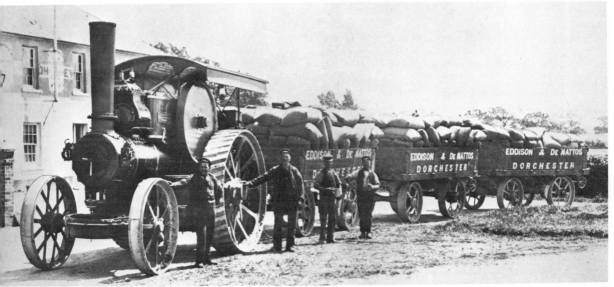

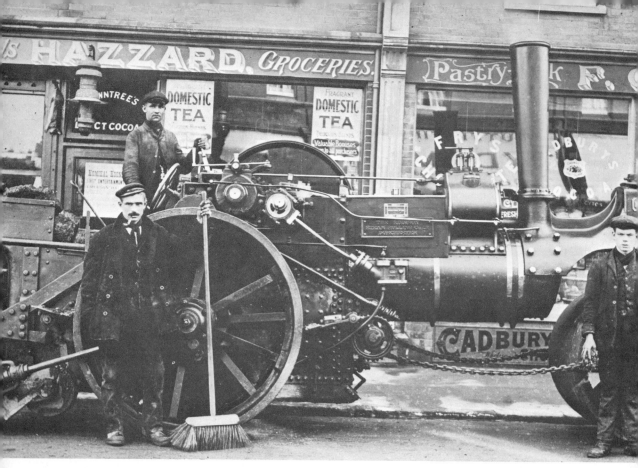

110 Roller No. 50, driven by S.B. Dodge, in Ashley Road, Parkstone in 1907. It was supplied by
Eddison and de Mattos of Dorchester who had become by the turn of the century the largest firm of
roller hirers in the country. The major road improvements being carried out around this time, notably
in the growing use of tarmacadam, meant that this side of their business replaced steam ploughing in
importance

111 Hauling timber, near Shaftesbury, *c.* 1910

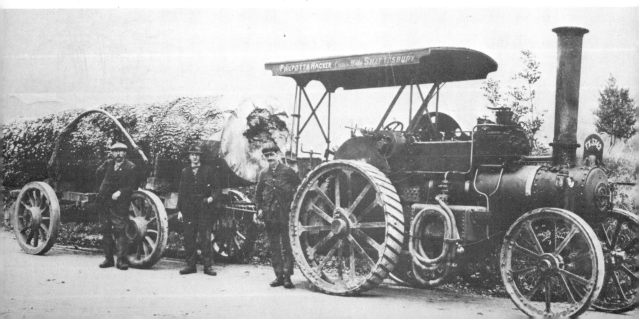

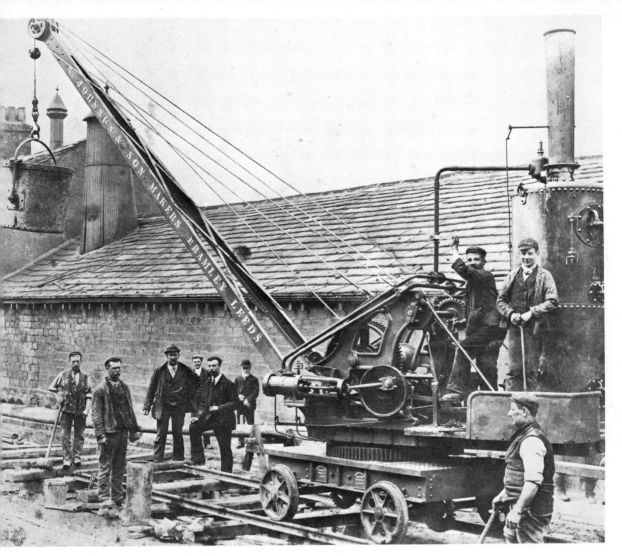

112 Steam crane at Castletown, Portland

THE ARMY

113 A military convoy
passing up Broad Street, Lyme
Regis, *c.* 1870. The blur at the
lower right-hand corner of the
picture is a speeding outrider.
The first shop on the left is the
Photographic Institution
belonging to Henry and Jonas
Walter, while next door in The
Bazaar toys and fancy goods
were sold

114 *Right* Troops of the
Argyle and Sutherland
Highlanders on manoeuvres
entering Shaftesbury, 1898

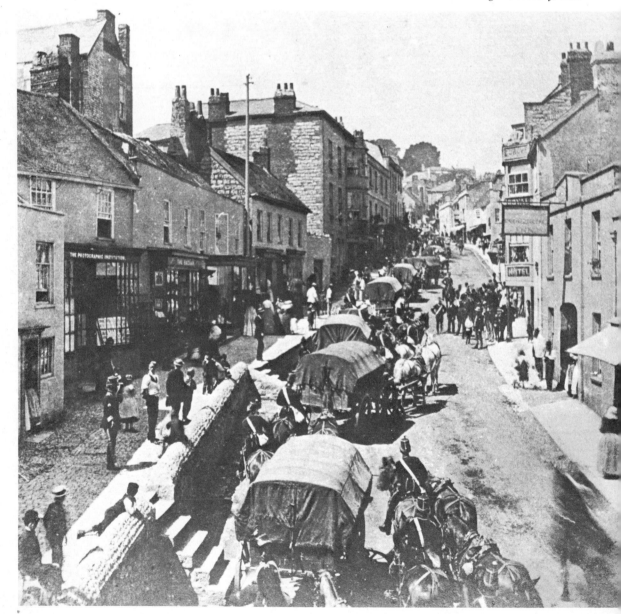

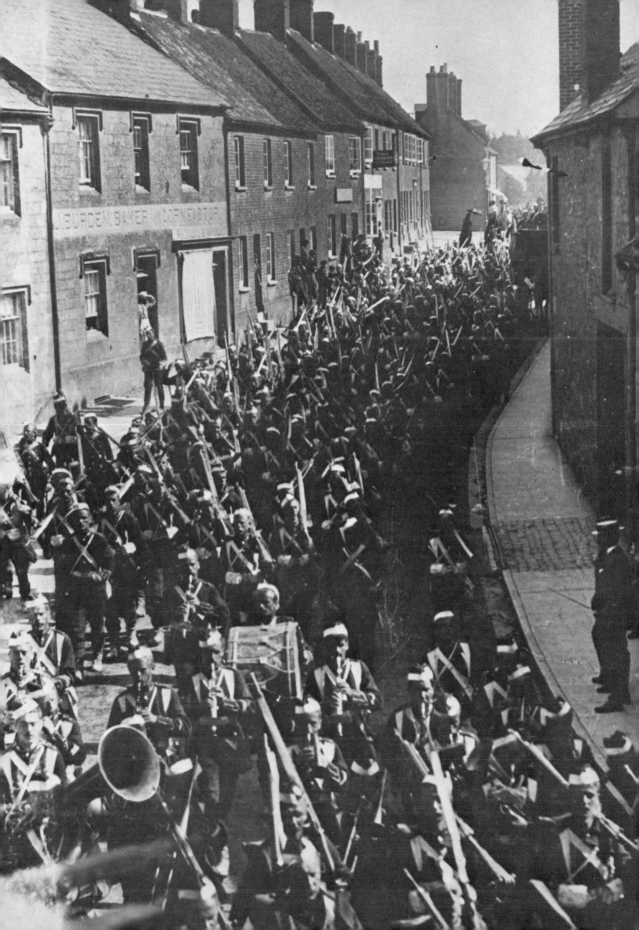

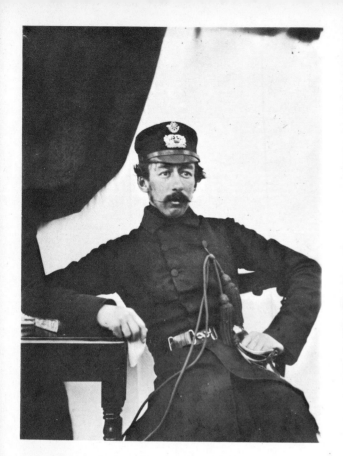
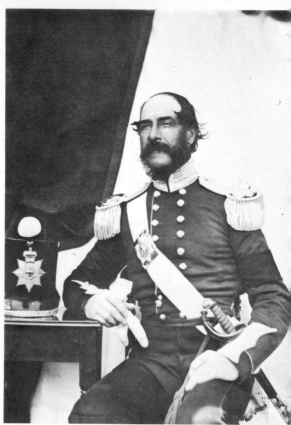
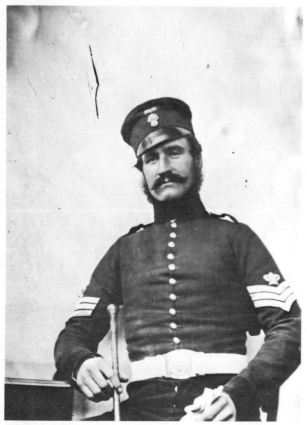
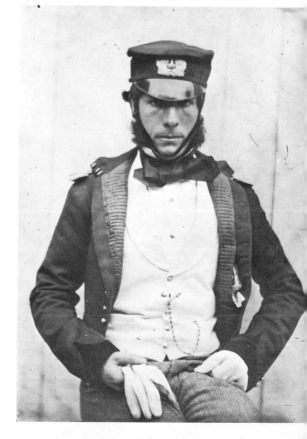

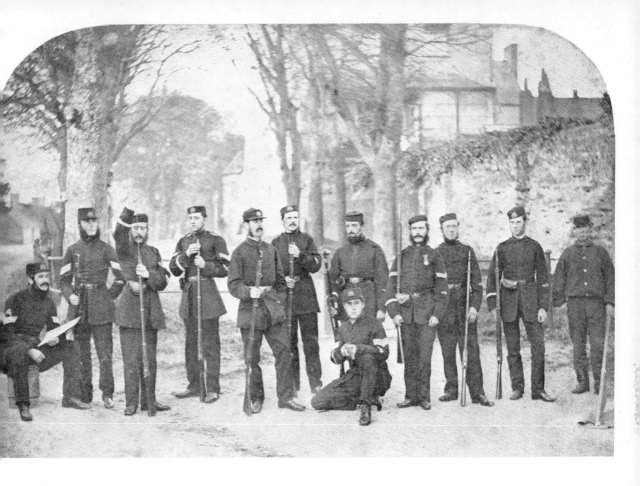

Left Members of the Dorset
Militia photographed by Major
John Warry of Holwell in the
1850s and '60s

115 Officer of the Light
Company

116 Officer in full dress, pre
1855

117 Staff Sergeant Instructor

118 Officer showing method
of wearing staff jacket open for
dinner. It is from this custom
that mess dress evolved

119 *Above* No. 3 Corps of the
Dorsetshire Rifle Volunteers in
Dorchester, 1863

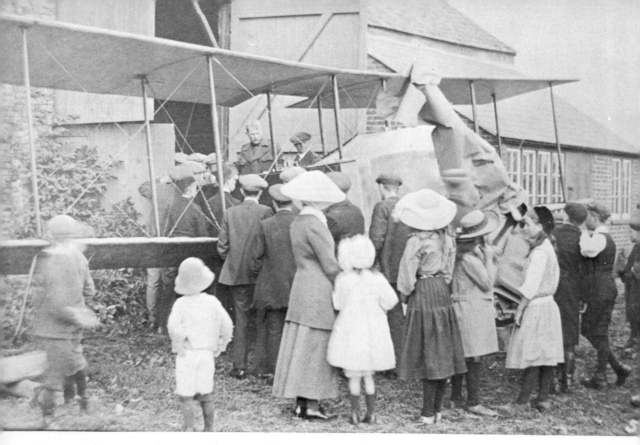

120 Major Webb of the Royal Aero Corps stands behind the biplane in which he has landed at Wimborne en route from Salisbury Plain to join the naval operations at Lulworth, August 1912

121 *Right* Captain Templer and niece Hebe, Bridport 1860

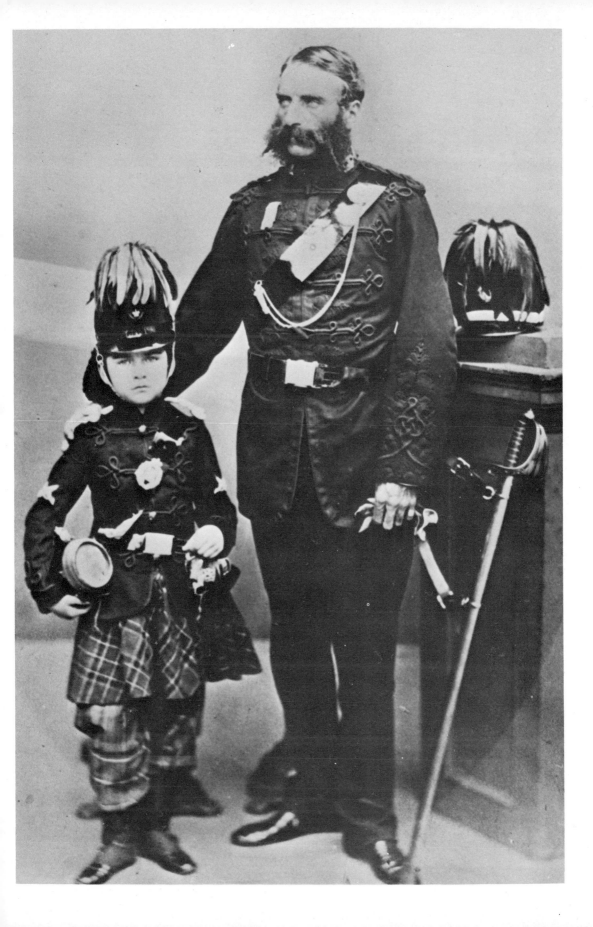

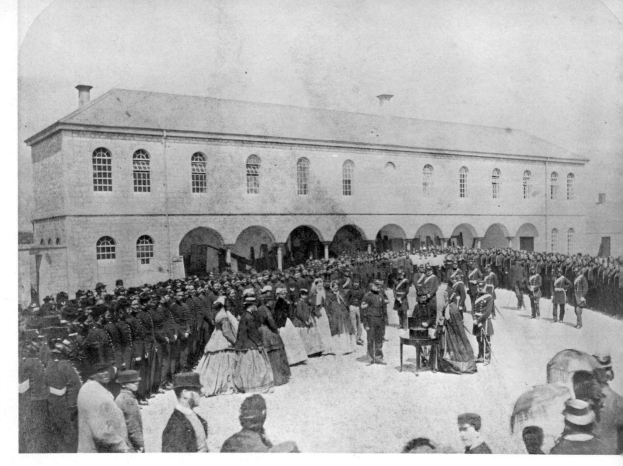

122 Presentation made to Mrs Bingham, the wife of the Colonel of the Dorset Militia, at Poundbury
Barracks, 17 May 1866. Mrs Bingham, concerned for the moral welfare of the men and to
counteract the twin evils of idleness and beer, opened a coffee-stall and reading room and often asked
William Barnes to give readings of his poems.

When you've a-handled well your lock,
An' flung about your rifle stock
Vrom han' to shoulder, up an' down;
When you've a-lwoaded an' a-vired,
Till you do come back into town,
Wi' all your loppen limbs a-tired,
An' you be dry an' burnen hot,
Why here's your tea an' coffee pot
At Mister Greenen's penny till,
Wi' Mrs. Bingham, off o' drill.
from William Barnes, 'The Do'set Militia'

123 *Right* Troops entering Shaftesbury just before the Boer War, 1898. The men have just
completed a 20-mile forced march from Salisbury and now, tired and thirsty, they have broken ranks
in search of water

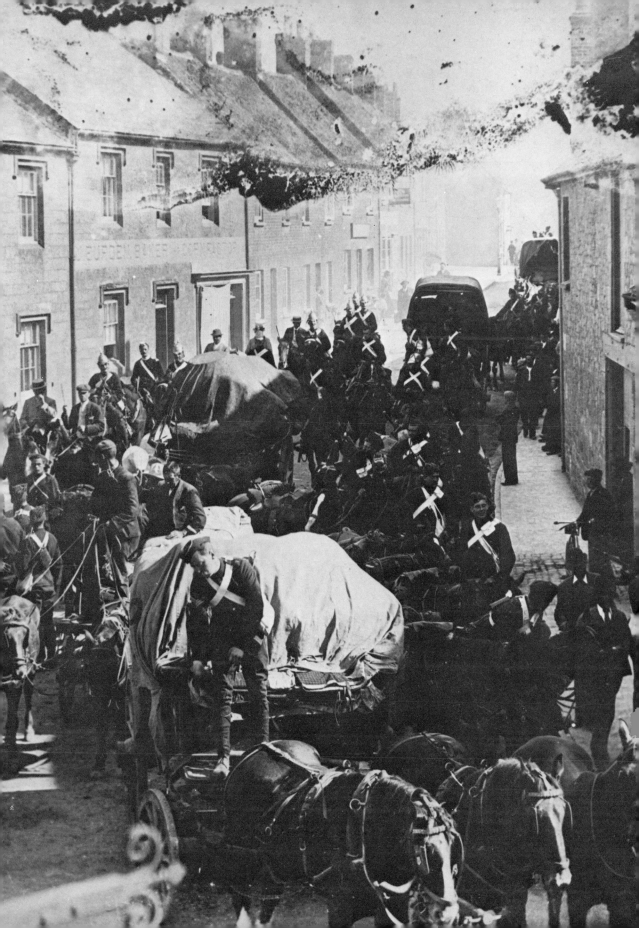

SPORT AND ENTERTAINMENT

124 Wimborne cricket team, *c.* 1900

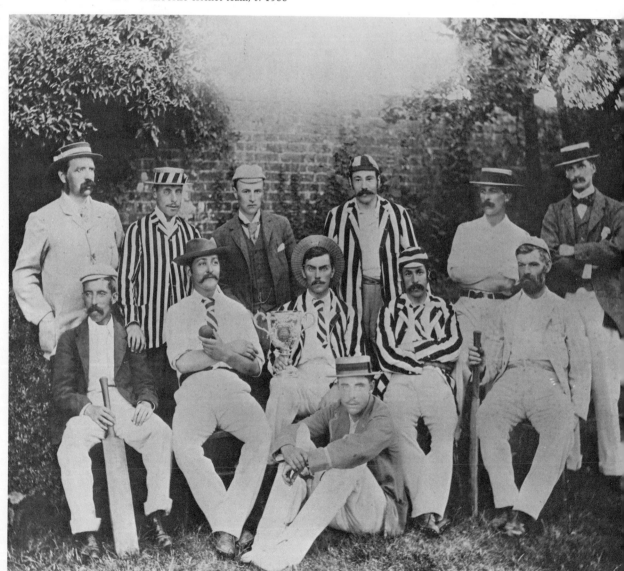

125 Abbotsbury Garland Day, 1903. On 13 May (Old May Day) it used to be the custom for the children belonging to the crew of each fishing boat in the village to prepare a flower garland which they would carry from house to house for money and gifts. The garlands would then be taken down to the boats which carried them out into the bay where they were cast upon the waters – an offering to a long forgotten god for a rich fish harvest. By the time this picture was taken, the custom had lost the last vestige of its pagan origins; the garlands were now used to decorate the church

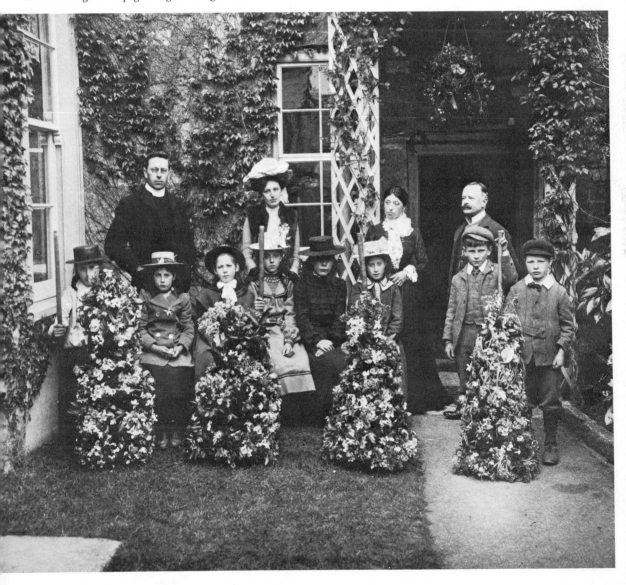

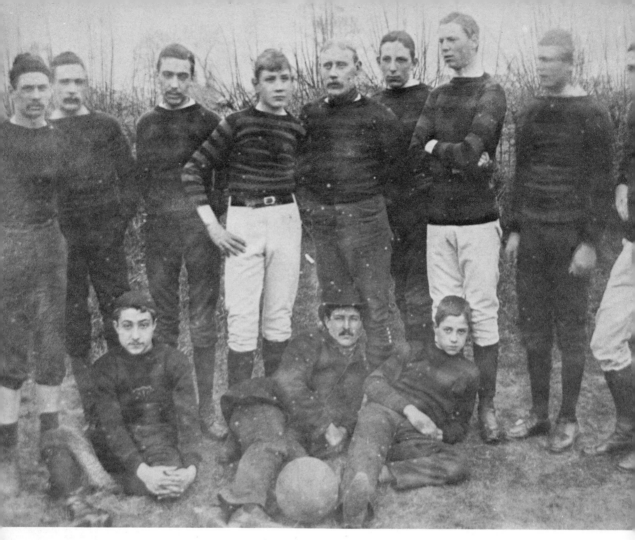

126 Wareham football team, *c.* 1898

127 *Right, above* An entertainment at the Larmer Grounds, *c.* 1900. In the midst of his Cranborne Chase estates, General Pitt-Rivers created a rustic fantasy with a classical temple, bandstand, open-air theatre ('where occasionally Miss Winifred Emery and Mr. Cyril Maude, or the Westminster Singers, might be heard'), summer-houses, Indian pavilions and tea-houses with 'German skittles and swings in the shrubbery'. No charge was made to visitors to this rural wonderland who flocked there in large numbers, from the surrounding towns and villages, in the 1890s

128 *Right* The Final Tableau of the Sherborne Pageant, held among the ruins of Sherborne Castle in 1905. St Aldhelm had become the first bishop of Sherborne 1200 years before and the Pageant, the first of its kind with over 500 participants and 'armour kindly lent by H. Beerbohm Tree Esq.', was organised to commemorate this event

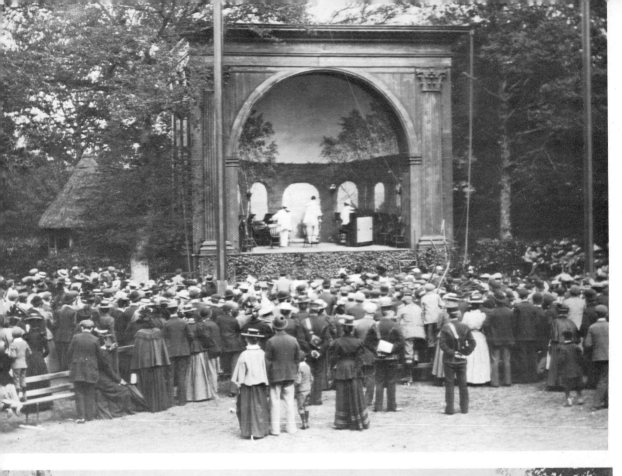

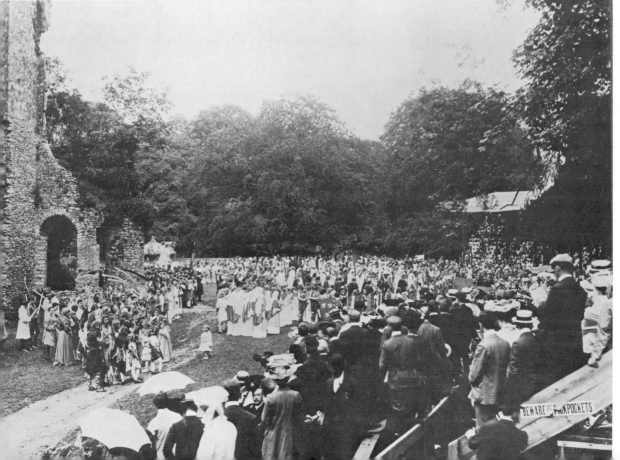

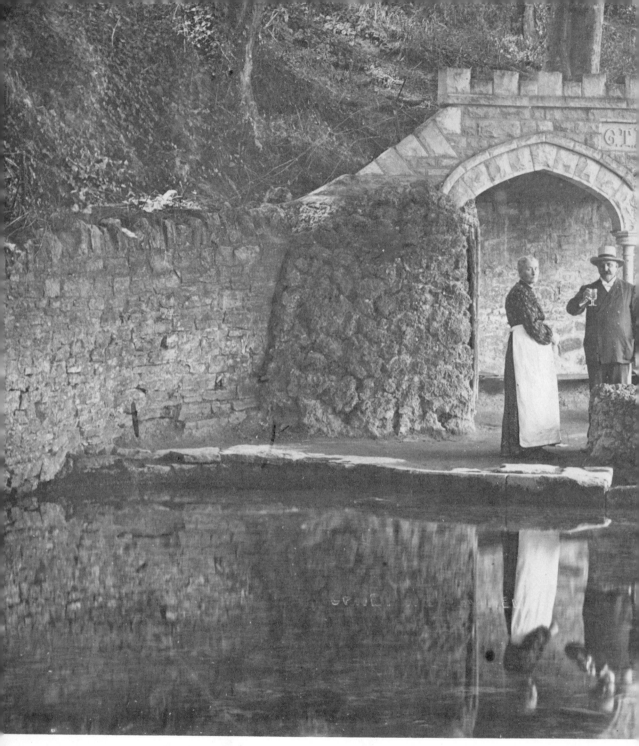

129 The Wishing Well, Upwey, *c.* 1900. Sir Frederick Treves wrote of it in a characteristic fashion. 'A seat placed under two ridiculous stone arches has been erected for the benefit of the tripper. For the benefit of the villager, on the other hand, the following ritual has been introduced, which has proven to be more lucrative than a mere gazing at the waters. The wisher receives a glass of water from the custodian of this Fons Bandusiae, he drinks it with appropriate giggling, empties the glass by throwing the water over his left shoulder, and, most important of all, makes an offering of money to the keeper of the well.'

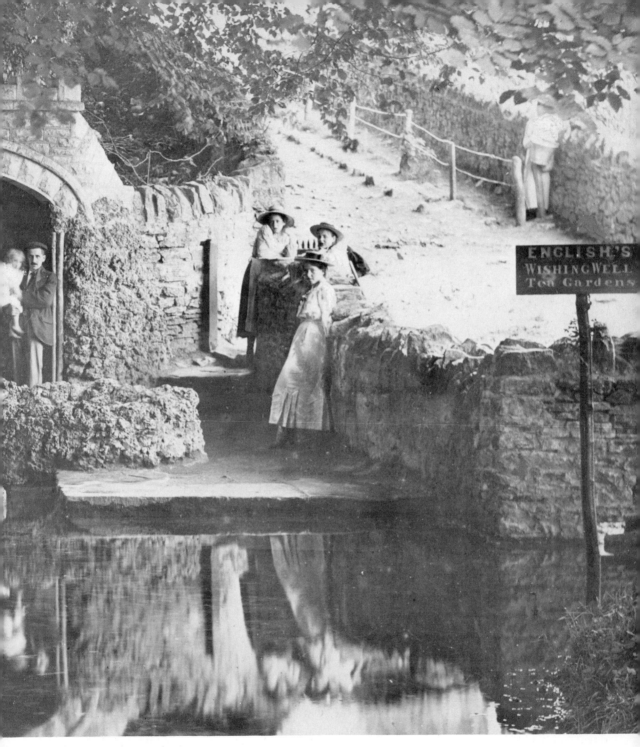

An' oh! what vo'k his mossy brim
Ha' gathered in the run o' time!
The wife a-blushen in her prime;
The widow wi' her eyezight dim;
 Maidens dippen,
 Childern sippen,
Water drippen, at the cool
Dark wallen ov the little pool.'
from William Barnes, 'The water-spring in the leane'

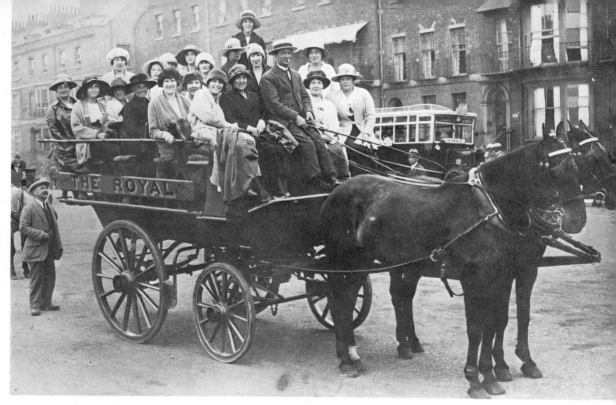

130 Joe Godden setting off from the Esplanade, Weymouth to the Wishing Well at Upwey

131 A char-à-banc of holiday-makers at Upwey. No holiday at Weymouth in the early years of this century was complete without a shilling trip to Upwey to visit the Wishing Well and to eat a strawberry tea

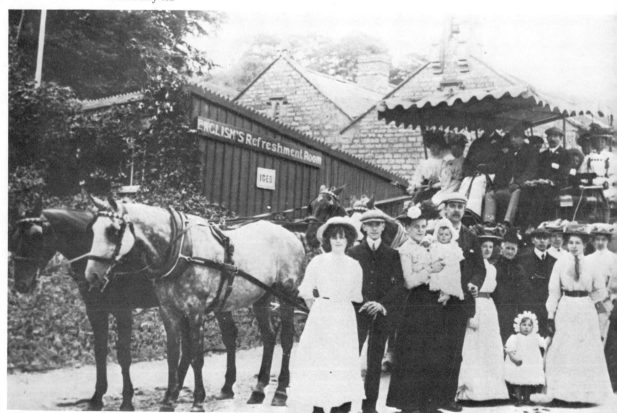

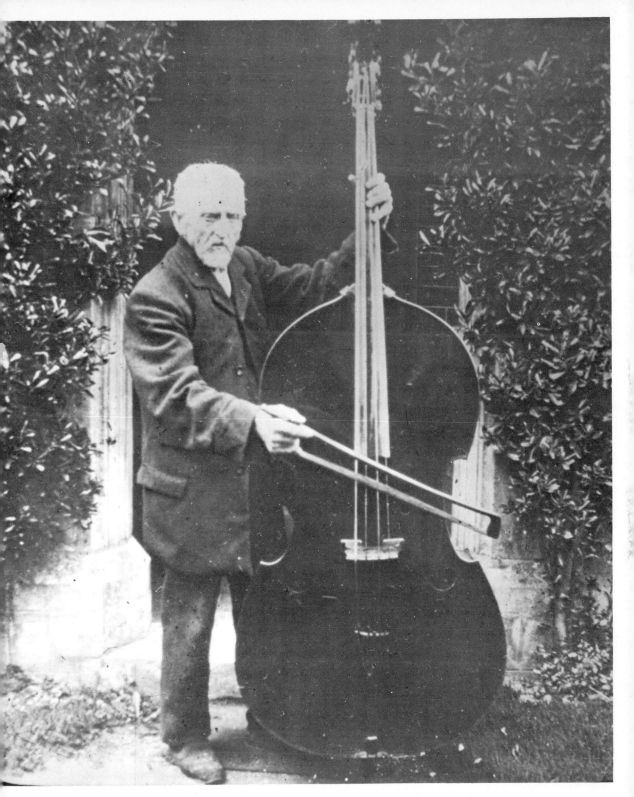

132 A bass-viol player

133, 134 *Below* 135, 136 *Right* Scenes from Woodbury Fair, *c.* 1908. The fair, held atop the ancient earthworks of Woodbury Hill near Bere Regis, was once an event of great importance in the calendar of the surrounding countryside. Then it would last five days, attracting pedlars and showmen from all over the country, and thousands of sheep were sold there every year. It had long since fallen into a decline

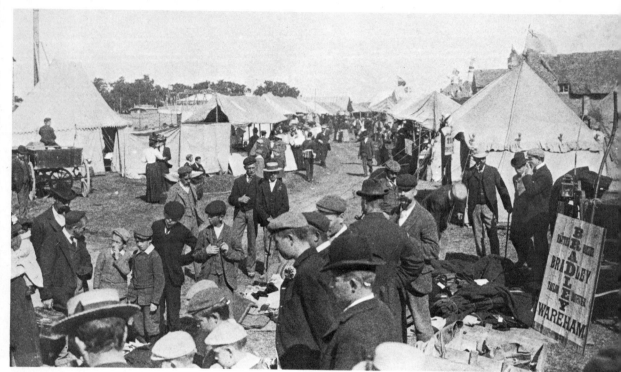

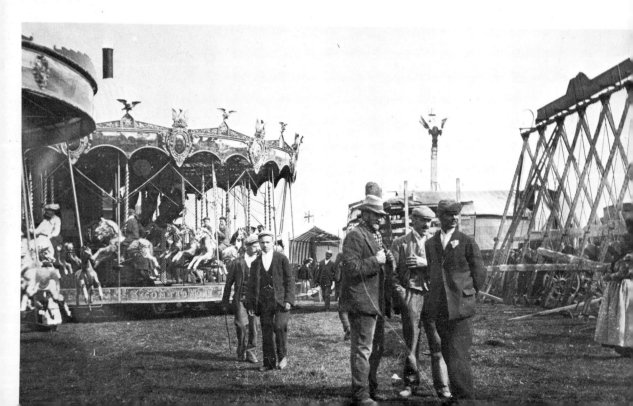

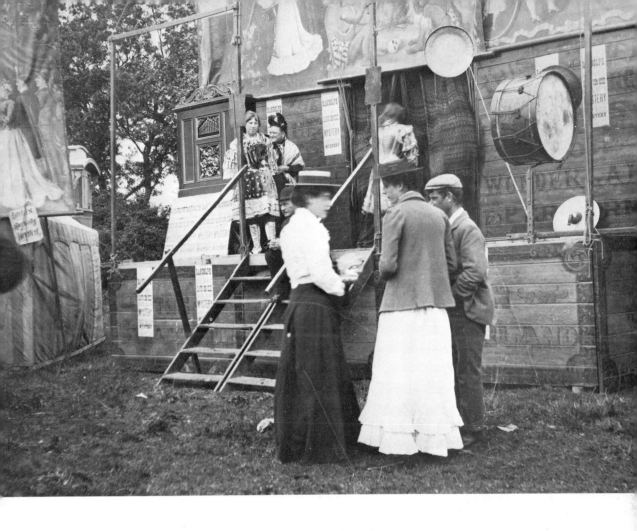

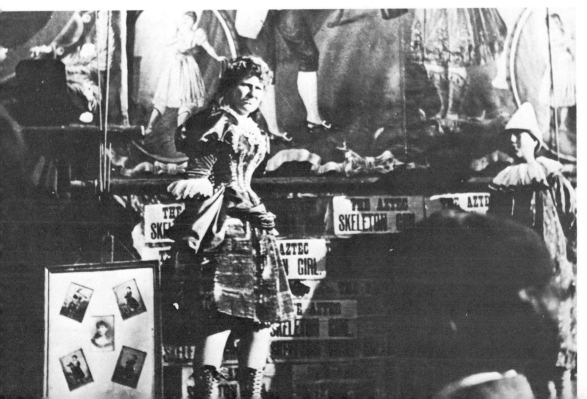

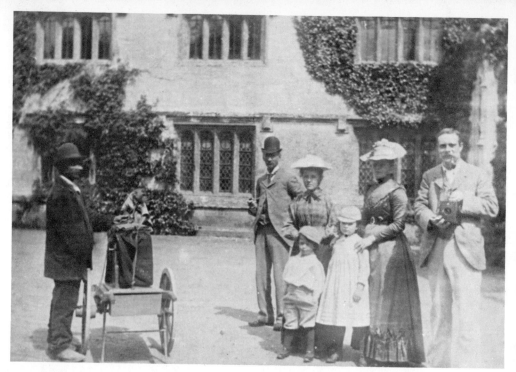

137 Italian organ-grinder with his monkey at Athelhampton, *c.* 1900. He may be Joseph Fuoco, who ran a lodging house in Gold Hill, Shaftesbury and travelled around the county at the turn of the century

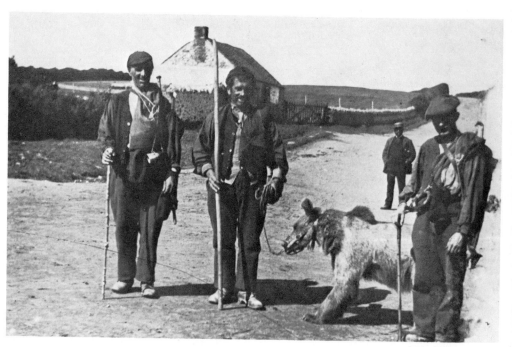

138 Performing bear and keepers near Chickerell *c.* 1900. The keepers are probably Russian

139 *Right* Mr Burchell, an itinerant entertainer who was a familiar sight around Wimborne at the turn of the century

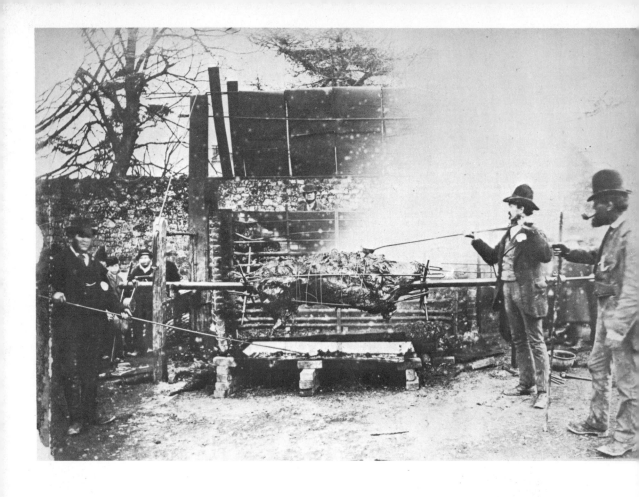

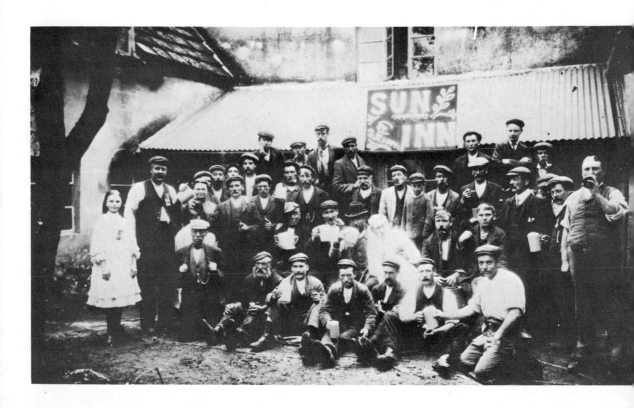

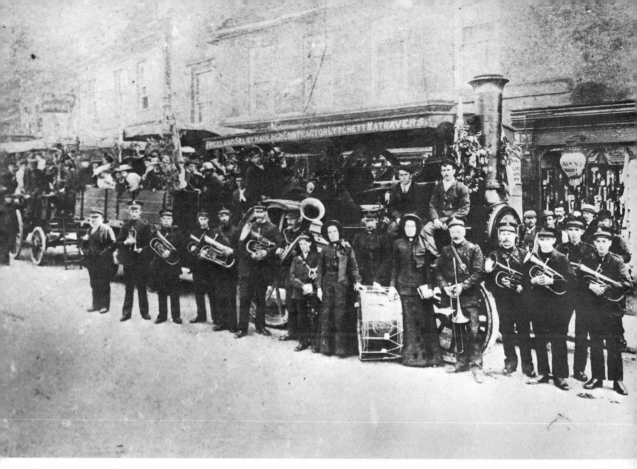

140 *Left, above* Roasting an ox in the Old Cattle Market, Shaftesbury on 7 March, 1877. The occasion was the marriage of Lady Theodora Grosvenor, daughter of the second Marquis of Westminster, to T. Merthyr Guest, Esq.

141 *Left* Behind the Sun Inn, Beaminster, *c.* 1907. Mr Russell, the landlord, is the man with the medals on the left

142 Salvation Army outing, Wimborne

143 *Overleaf* In the garden of a public house near Wimborne. Note the Codd mineral water bottles with their glass marble stoppers. They were supplied by the Dorset Mineral Water Company of Poole

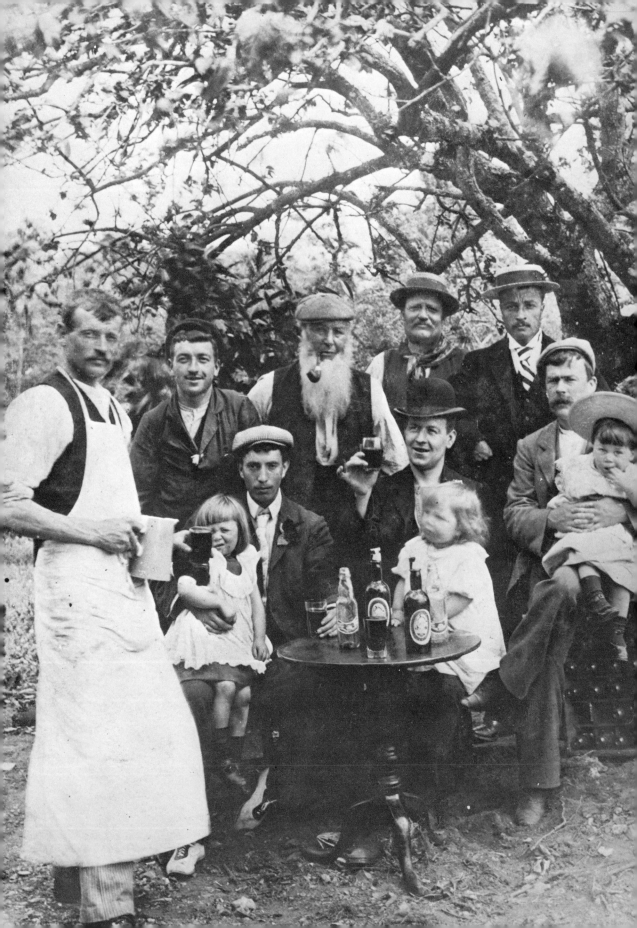